Harry Potter ™

FILM VAULT

VOLUME 1

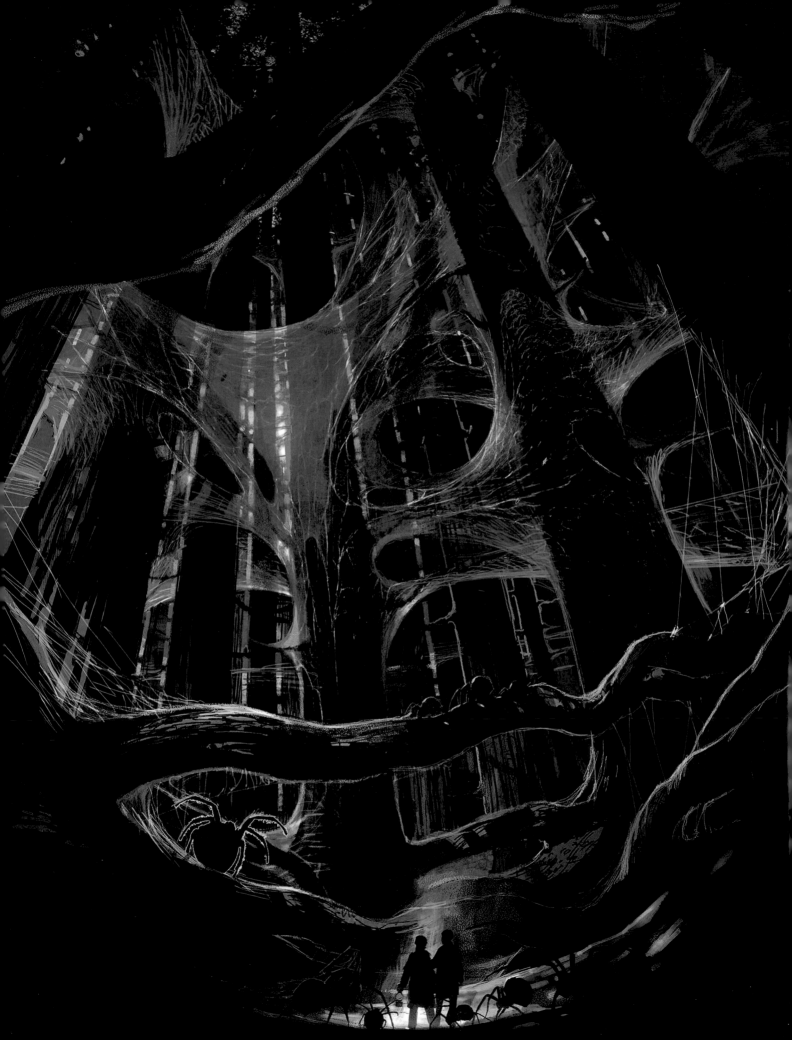

Harry Potter

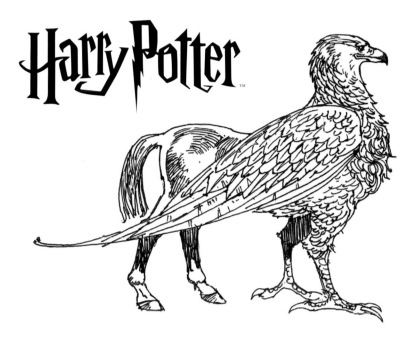

FILM VAULT

Volume 1

Forest, Lake, and Sky Creatures

By Jody Revenson

WIZARDING WORLD

INSIGHT EDITIONS

San Rafael, California

INTRODUCTION

I n the forests and lake surrounding Hogwarts School of Witchcraft and Wizardry, and in the skies above, magical creatures gallop, crawl, swim, and soar. Elegant, skeletal Thestrals bring up their young in the Forbidden Forest, and Grindylows play among myriad strands of kelp in the Black Lake. Thousands of Acromantula, fathered by the largest of all these spiders, Aragog, scuttle over tree roots and broken branches. And dragons swoop through the air when they're brought in for an ancient school competition.

Harry Potter encounters all these creatures during his years at Hogwarts, and it was up to visual and digital artists and creature designers, aided by sculptors, painters, and cyberscanners, to bring them all to cinematic life. So where did they start?

"Research was the greatest help to imaging the creatures," says concept artist Adam Brockbank. "It's a necessity for ideas, and starts off the process." The goal of the artists was to imbue every on-screen creature, no matter how fantastical, with naturalism and believability. "When you're refining your ideas, you can be looking very closely at the musculature of certain animals to inform your drawing," he continues. "I know [visual development artists] Rob Bliss and Dermot Power studied horse anatomy and musculature for the Thestrals and the hindquarters of Buckbeak, respectively." Credibility was key.

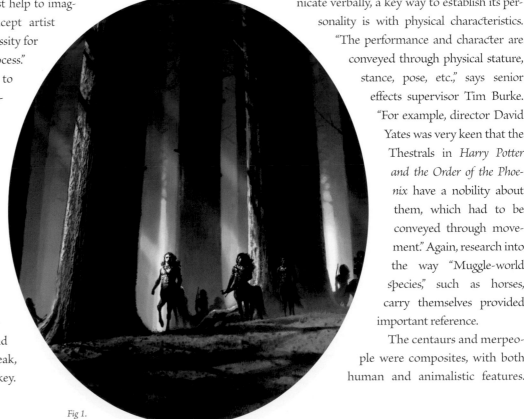

Personality was just as paramount. Before starting to imagine any creature, Rob Bliss would ask himself, "What is the character of the creature? Is it good or bad, intelligent or stupid?" Very few creatures can speak English, with Aragog being the exception, so when a character can't communicate verbally, a key way to establish its personality is with physical characteristics. "The performance and character are conveyed through physical stature, stance, pose, etc.," says senior effects supervisor Tim Burke. "For example, director David Yates was very keen that the Thestrals in *Harry Potter and the Order of the Phoenix* have a nobility about them, which had to be conveyed through movement." Again, research into the way "Muggle-world species," such as horses, carry themselves provided important reference.

The centaurs and merpeople were composites, with both human and animalistic features.

Fig 1.

4

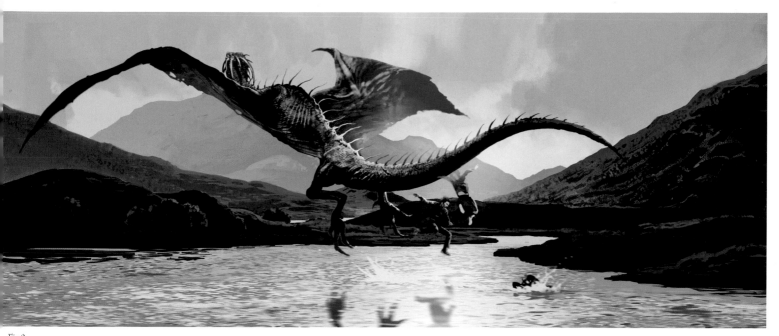

Fig 2.

Both of these creatures have the top half of a human with the bottom half of a horse or fish, and the traditional approach in films is to plop one species atop the other. Adam Brockbank wrestled with this when visualizing the centaurs: "It was that meeting point between the human part and the horse part," he remembers. "That's the bit you've really got to make work." So, the artists for the Harry Potter films went for a different design, bringing human features into the animal half and animalistic features into the human half, and giving particular thought to how the musculature and skin textures would work together.

"But the design is not just one person's thing," says Nick Dudman, creature effects supervisor and head of the creature shop. "Our concept artists provide a range of designs, and then [production designer] Stuart Craig and I and anyone else who's involved, tie that all together and it evolves. By the time it reaches the set, the creature has been designed by a huge number of people. Everyone's contributed. And if it looks real and behaves real, then that's why—because you're not imposing one person's belief."

Throughout the ten years of filming Harry Potter's story, practical and digital technology advanced, and both had to be

considered when deciding how a creature would be brought to the screen. "There's financial and there's practical," says Dudman. "Can we build this thing? Will the laws of physics defeat you? Can you get it into the set? How will the actors work with it?" With these concerns, it's understandable that when a dragon needs to fly around the towers of Hogwarts castle, it's got to be CG, but when there's a fire-breathing dragon in a cage on the ground, Dudman and his team can handle it. And they always wanted to build one anyway.

Every creature was realized in a full-size version to aid with lighting and staging for a scene, and to provide a model for the digital artists to scan. Also, "actors today are practiced at acting against yellow tennis balls and have a great power of imagination, but having something concrete is even better," says producer David Heyman. "In the digital world, we have to wait many months for completed shots," he continues, "so it's great to have something on set. But it's important to find a balance, and they're both used." There's a Hippogriff that sits in a pumpkin patch and a Hippogriff that soars around the towers of Hogwarts, "and hopefully you will never know the difference," he laughs.

Page 2: Harry and Ron gaze at the hollow that houses Aragog and his descendants in artwork by Dermot Power for *Harry Potter and the Chamber of Secrets*; Fig 1. The centaurs of the Forbidden Forest, concept art by Adam Brockbank for *Harry Potter and the Order of the Phoenix*; Fig 2. A Ukrainian Ironbelly drops Harry, Ron, and Hermione near Hogwarts after their escape from Gringotts Bank, visual development art by Adam Brockbank for *Harry Potter and the Deatlhy Hallows – Part 2*.

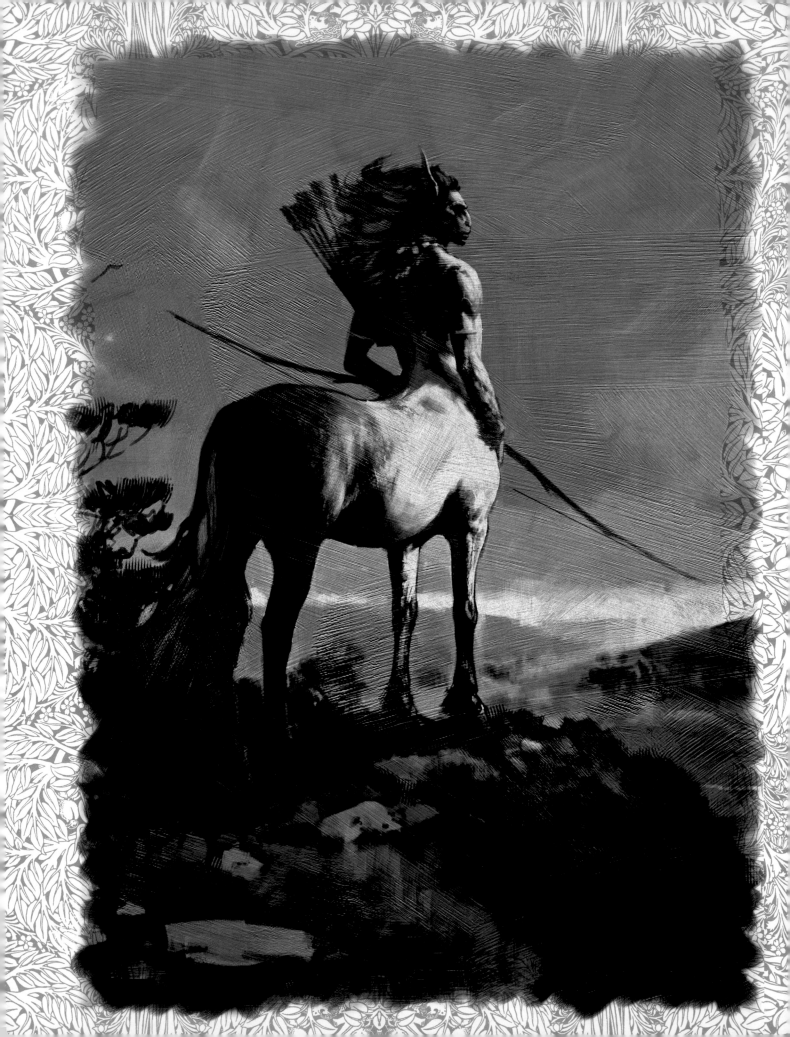

CHAPTER I

FOREST DWELLERS

In the Harry Potter films, the Forbidden Forest lies on the outskirts of the grounds of Hogwarts School of Witchcraft and Wizardry. Home to an abundance of creatures, the forest offers shelter and protection to herds of centaurs, unicorns, Thestrals, and Acromantula. Adjacent to the forest is the paddock used for the Care of Magical Creatures classes.

Centaur

Centaurs are a species of creature that unites human and equine aspects. Harry Potter meets the centaur Firenze in *Harry Potter and the Sorcerer's Stone*, while he is serving detention in the Forbidden Forest. When Harry encounters Voldemort feeding from a unicorn, Firenze saves him from the Dark Lord's attack.

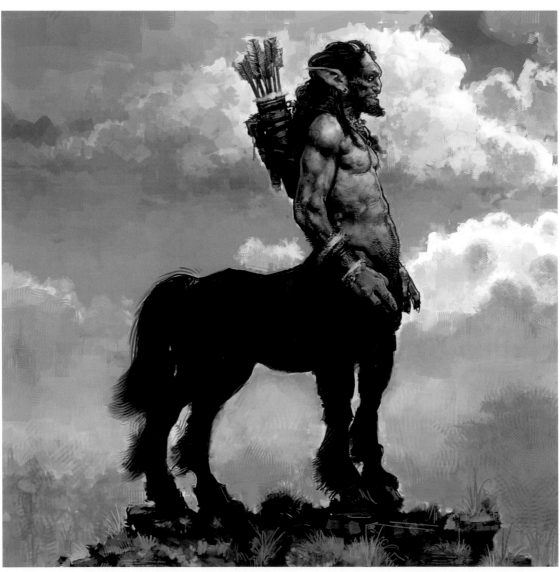

Fig 1.

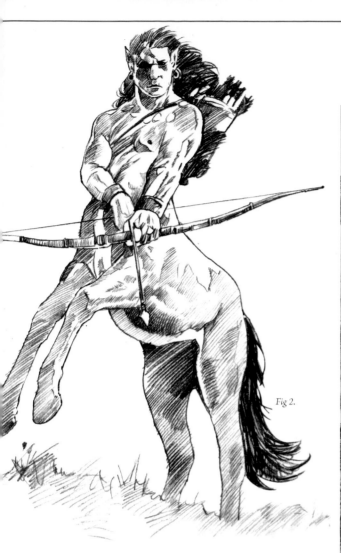

Fig 2.

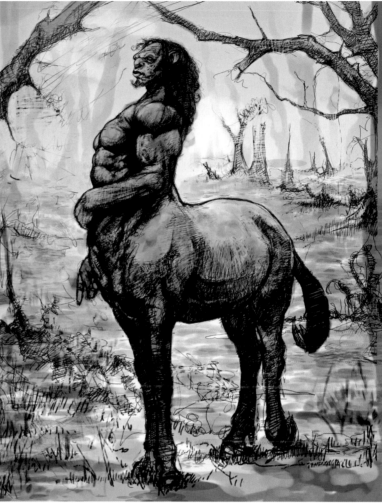

Page 6: The centaur Bane painted by Adam Brockbank; Centaur concepts by Rob Bliss (Fig. 1) and Adam Brockbank (Fig. 2) for *Harry Potter and the Order of the Phoenix*; Fig 3. Centaur concept art by Paul Catling for *Harry Potter and the Sorcerer's Stone*.

Fig 3.

Centaurs also play a key role in the comeuppance of Dolores Umbridge in *Harry Potter and the Order of the Phoenix*. When Harry and Hermione Granger tell Umbridge to follow them into the forest to see Dumbledore's Army's "secret weapon," they encounter a herd of centaurs, led by Bane. Umbridge's prejudice against the creatures leads to a heated exchange, and the centaurs drag her away into the depths of the forest.

The creature designers never considered centaurs to be half-breeds (as Dolores Umbridge did). In their early research of the mythological beings, they noted that ancient Greek and Roman artists had essentially stacked the top half of a man onto the body of a horse when portraying the creature. In a reverse of this traditional rendering, the designers conceived the centaurs not as a humanized horse, but as an animalized human. The centaurs' faces in the films are long, with a broader forehead; flatter cheeks, nose, and jawline; and eyes set farther apart than a human's. Instead of skin, the horse's pelt and coloration envelop the entire creature, not just the bottom half. Pointed ears are set high up on the head.

Firenze in *Harry Potter and the Sorcerer's Stone* was computer-generated, but the process changed for *Harry Potter and the Order of the Phoenix*. To depict Bane and Magorian, the creature shop created two full-size models—called maquettes—of the centaurs, which were used for cyberscanning into the computer. The maquettes were also placed in the forest set for lighting reference and to give the actors an "eyeline" to follow to the creatures.

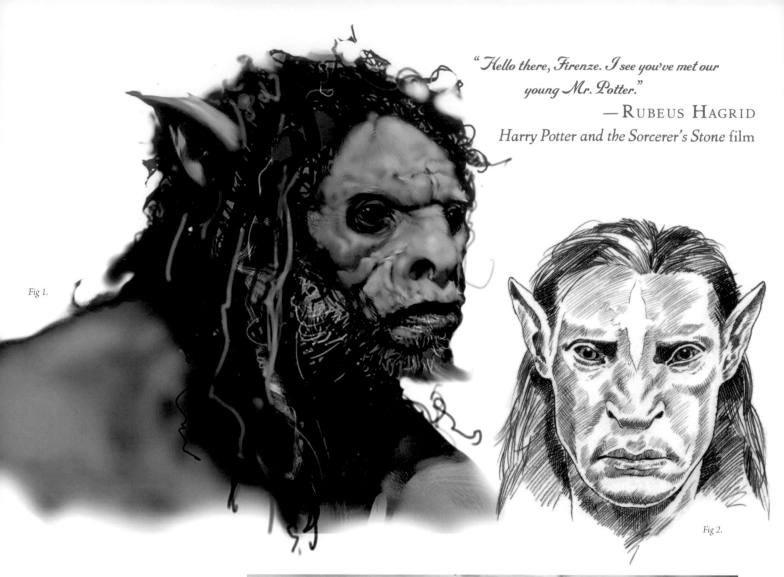

"*Hello there, Firenze. I see you've met our young Mr. Potter.*"

—RUBEUS HAGRID
Harry Potter and the Sorcerer's Stone film

Fig 1.

Fig 2.

Centaur head and face studies by Paul Catling (Figs 1. & 3.) for *Harry Potter and the Sorcerer's Stone*, and Adam Brockbank (Fig 2.) for *Harry Potter and the Order of the Phoenix*; Fig 4. The centaur Magorian dressed in weaponry and jewelry for *Order of the Phoenix*, illustrated by Adam Brockbank; Fig 5. Sketch of Centaur jewelry by Adam Brockbank; Figs 6. & 7. Centaur head studies by Adam Brockbank for *Order of the Phoenix*, paying special attention to blending their human and equine characteristics.

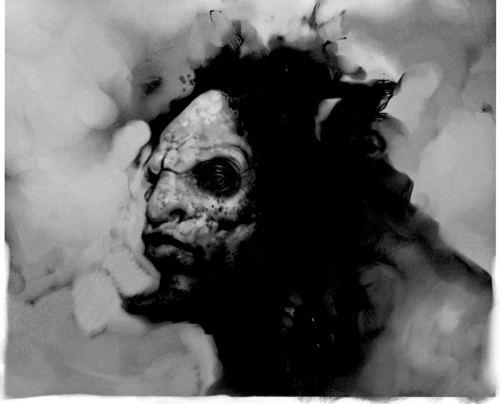

Fig 3.

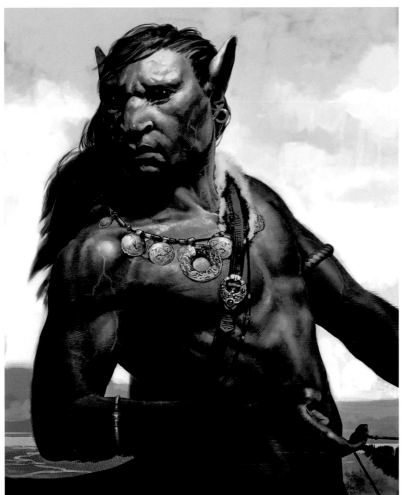

Fig 4.

Fig 5.

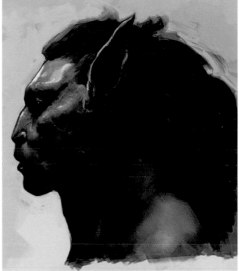

Fig 6.

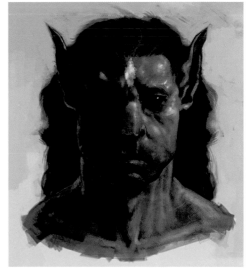

Fig 7.

To create their pelts, the centaur models were "flocked," a laborious process that involves wetting down the entire model with glue, sending an electrical charge through it, and then firing oppositely charged hairs at the model. This process causes the hairs to stick and stand on end. These hairs must be combed into their desired direction before the glue dries, which is a matter of only forty minutes. If the procedure is not accomplished within this time period, it has to start again from scratch. It took a team of six people and many rehearsals to insure that the correct combinations of hair colors and hair lengths bonded to their assigned areas. Then, longer hairs were punched into the models one at a time, followed by air-brushed artwork. It took the costume and prop departments eight months and a crew of more than forty people to get from the initial sculpt of the centaurs to their final fittings with handcrafted weapons and jewelry.

During the skirmish in the forest, Dolores Umbridge casts the *Incarcerous* Spell on Bane, which causes a rope to wrap around the centaur's neck, choking him. For this scene, the creature designers researched how a stallion would react to this situation. They learned that a human would respond differently than a horse if lassoed and restrained. Whereas a horse would move downward, a man would react by jumping up and straightening his back. Bane's physical responses as an animalized human were thus a blend of these two physical reactions.

FAST FACTS

CENTAUR

✶

I. FIRST FILM APPEARANCE: *Harry Potter and the Sorcerer's Stone*

II. ADDITIONAL FILM APPEARANCE: *Harry Potter and the Order of the Phoenix*

III. LOCATION: Forbidden Forest

IV. DESIGN NOTE: The designers wanted the centaurs to have the sweaty, glistening coats associated with thoroughbred racehorses.

V. DESCRIPTION FROM *HARRY POTTER AND THE SORCERER'S STONE* BOOK, CHAPTER FIFTEEN:
"And into the clearing came—was it a man, or a horse? To the waist, a man, with red hair and beard, but below that was a horse's gleaming chestnut body with a long, reddish tail."

Fig 2.

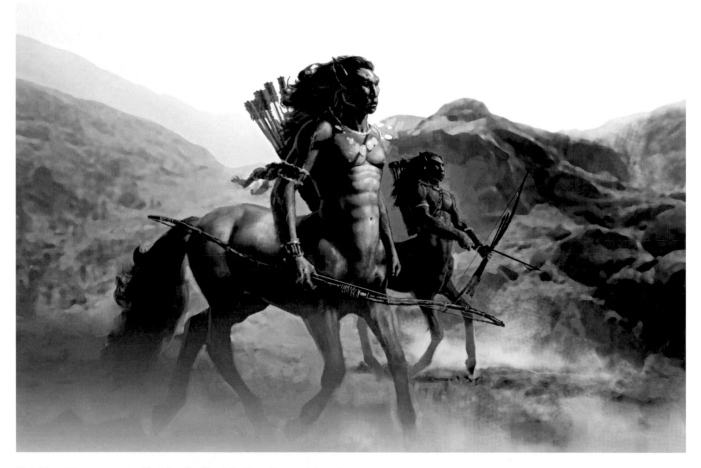

Fig 1. (above) Centaurs on patrol by Adam Brockbank for *Harry Potter and the Order of the Phoenix*; Fig 2. Early centaur study by Paul Catling for *Harry Potter and the Sorcerer's Stone*.

Figs 3. & 4. Maquettes for *Order of the Phoenix* of Magorian (top) and Bane (bottom); Fig 5. Harry Potter (Daniel Radcliffe) meets Firenze in a scene from *Sorcerer's Stone*; Fig 6. Centaur in the Forbidden Forest by Adam Brockbank for *Order of the Phoenix*. The visual development art often explored the character or creature within their environment's light conditions.

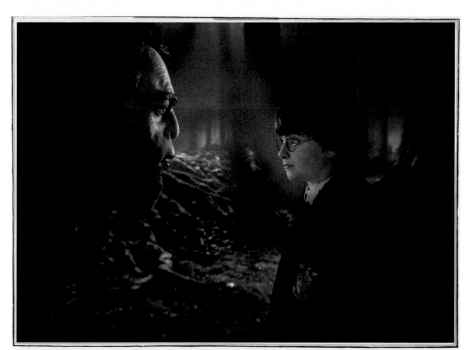

Fig 5.

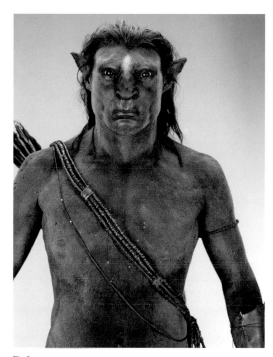

Fig 3.

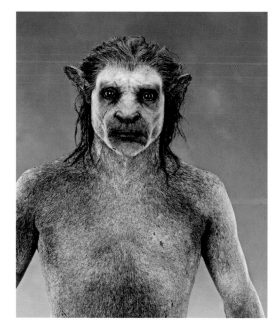

Fig 4.

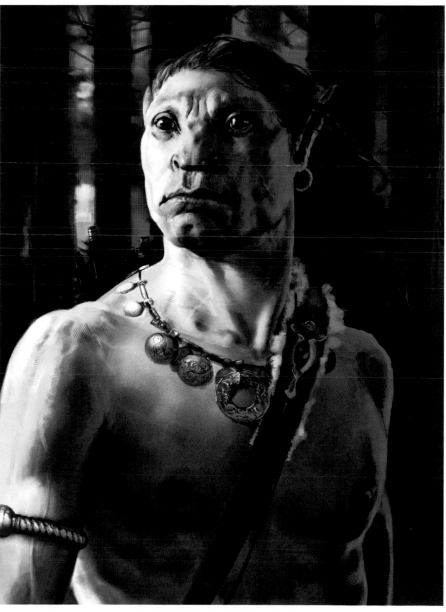

Fig 6.

Acromantula

A cromantula are a species of spider found in the world of Harry Potter that can grow to the size of an elephant. One of their unique features is their ability to converse with humans.

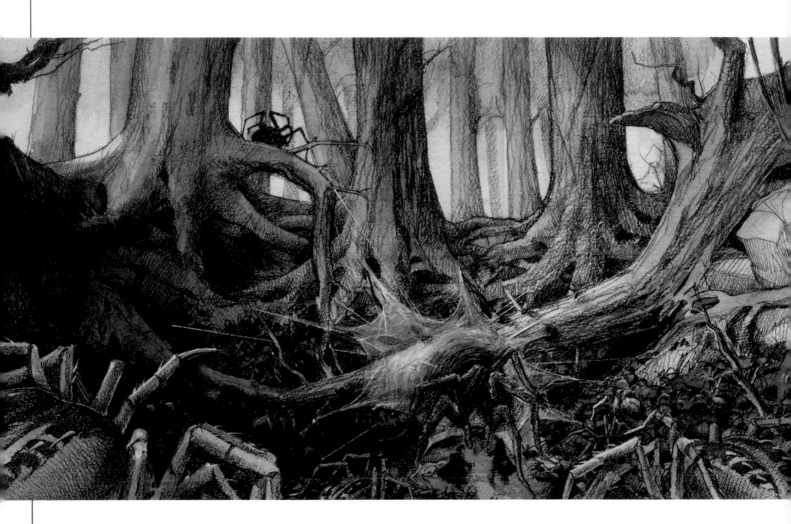

Fig 1. (above) Andrew Williamson portrays Harry and Ron's entrance into Aragog's hollow for *Harry Potter and the Chamber of Secrets*; Fig 2. A frightening perspective of the Acromantula by artist Dermot Power; Fig 3. Colored sketch of Aragog by Adam Brockbank; Fig 4. Crewmembers dress the set of the Forbidden Forest with young Acromantula for the filming of *Chamber of Secrets*.

"You heard what Hagrid said. Follow the spiders."
— HARRY POTTER
Harry Potter and the Chamber of Secrets film

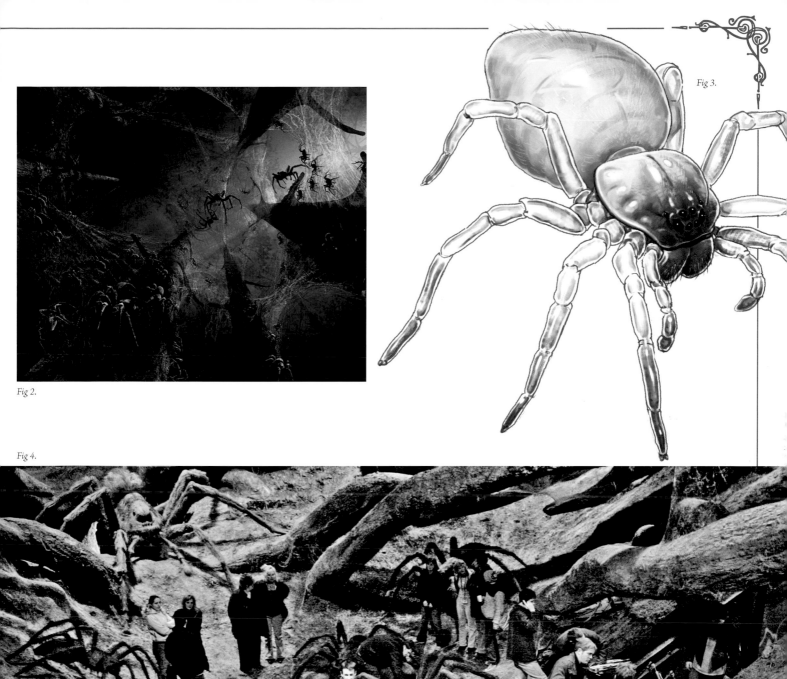

Fig 2.

Fig 3.

Fig 4.

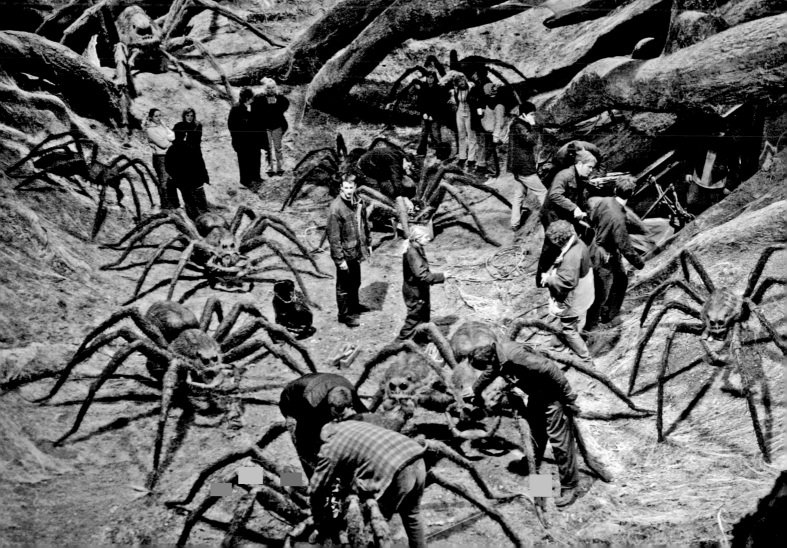

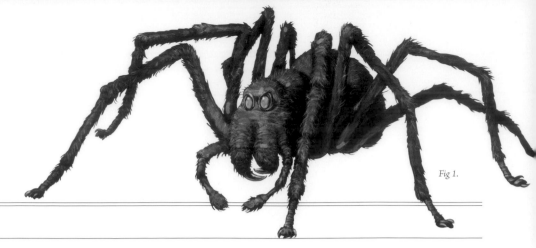

Fig 1.

ARAGOG

Aragog, the leader of a colony of Acromantula, was brought to Hogwarts by Rubeus Hagrid when he was a student, fifty years before the events of *Harry Potter and the Chamber of Secrets*. Harry and Ron encounter this beloved pet of Hagrid's during their second year at Hogwarts, as they try to uncover the truth behind the identity of the heir of Slytherin. Sadly, Aragog passes away from old age during the events of *Harry Potter and the Half-Blood Prince*.

When the designers read the script for *Harry Potter and the Chamber of Secrets* and discovered that a spider with an eighteen-foot leg span would be required, their obvious initial thought was that the creature would be computer-generated. Upon further consideration, however, it was decided that Aragog's myriad offspring would be digital, but not Aragog. The creature shop realized that constructing the Acromantula would be more economical than CGI, and it would also allow them to make Aragog walk and talk on a life-size scale.

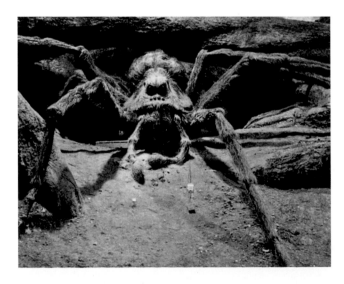

Aragog was crafted using an Aquatronic system that utilizes cables pumped with water instead of the oil-based system used in hydraulics. Aquatronics create a smoother, more graceful movement. Being the size of an elephant, Aragog needed to move with a similar unhurried elegance. The slow movements also imitated the quiet, menacing way that spiders creep around. The spider's back legs were manipulated by puppeteers while his forelegs were mechanical. These mechanical legs were operated by a motion-control device called a waldo that reproduces movements made by a controller. Then, Aragog was fitted onto a system that resembled a seesaw, with a counterweight on one end. The giant spider was placed into a depression in the soundstage, so when Aragog was tipped up, he literally walked forward.

A voice-activated system was installed in Aragog's head so that his mouth would move in synchrony with a broadcast recording of actor Julian Glover's voice as the character. This allowed Daniel Radcliffe (Harry Potter) and Rupert Grint (Ron Weasley) to act in real time with the creature.

Aragog was completely redesigned for *Harry Potter and the Half-Blood Prince* to show his age. The creature was cast in a urethane that allowed light to pass through in order to emulate the translucent glow of an actual dead spider. The same "hair" materials were used for both Aragog versions in *Chamber of Secrets* and *Half-Blood Prince*, including broom hairs for the finer ones and feathers with a coating of fluff and Lurex for the bigger, hairier ones. The hairs were inserted one at a time.

The script for *Half-Blood Prince* called for Aragog to be slid into a grave on a hill, so the designers knew that the Acromantula needed to be much heavier than the original in order to give the correct heft of a huge, upside-down, dead spider. The creature was such a beloved character that the design crew wore black armbands while the spider's final scene was filmed.

Fig 1. Visual development art of Aragog by an unknown artist for *Harry Potter and the Chamber of Secrets*; Fig 2. (above) The animatronic Aragog awaits his cue on the set of *Chamber of Secrets*.

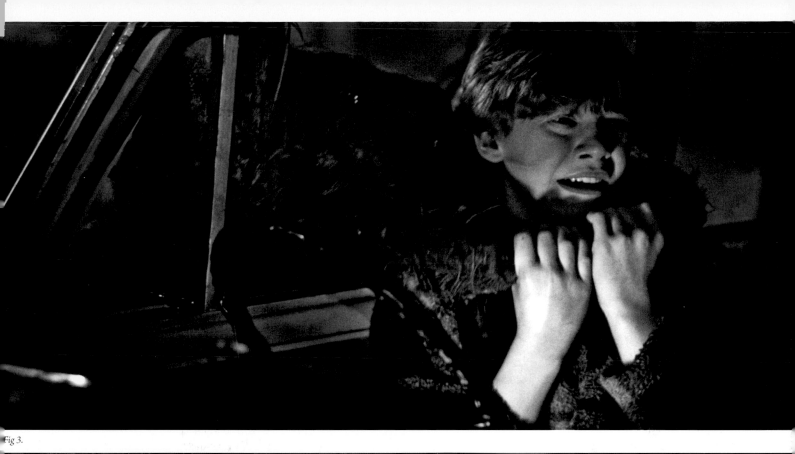

Fig 3.

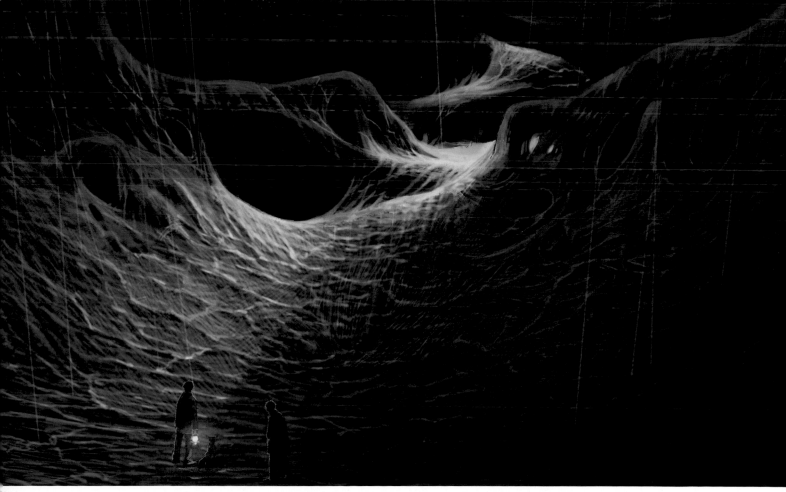

Fig 4.

Fig 3. Ron Weasley (Rupert Grint) is grabbed by an Acromantula through the driver's-side window of the flying Ford Anglia in a scene from *Chamber of Secrets*; Fig 4. Harry, Ron, and Fang come upon a heavily spiderweb-draped design of Aragog's lair in art by Dermot Power.

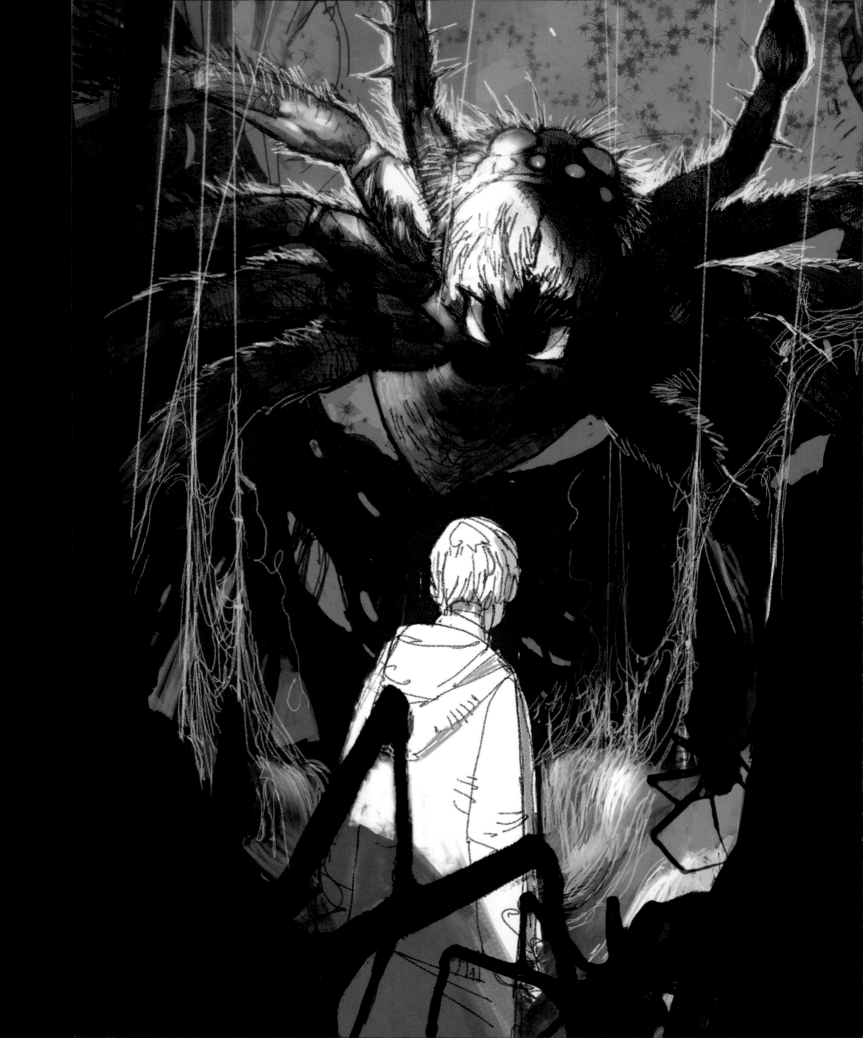

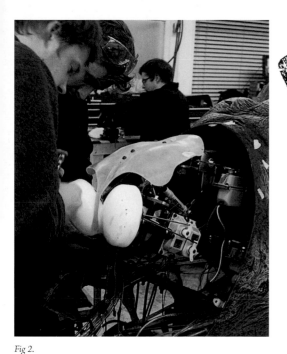

Fig 2.

FAST FACTS

ARAGOG

I. FIRST FILM APPEARANCE: *Harry Potter and the Chamber of Secrets*

II. ADDITIONAL FILM APPEARANCE: *Harry Potter and the Half-Blood Prince*

III. LOCATION: Forbidden Forest

IV. TECH TALK: The final version of Aragog in
Half-Blood Prince weighed three-quarters of a ton.

V. DESCRIPTION FROM *HARRY POTTER AND THE
CHAMBER OF SECRETS* BOOK, CHAPTER FIFTEEN:
*"And from the middle of the misty, domed web, a spider the size of a small
elephant emerged, very slowly. There was gray in the black of his body and
legs, and each of the eyes on his ugly, pincered head was milky white."*

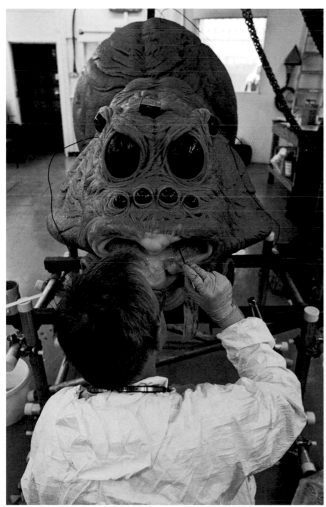

Fig 3.

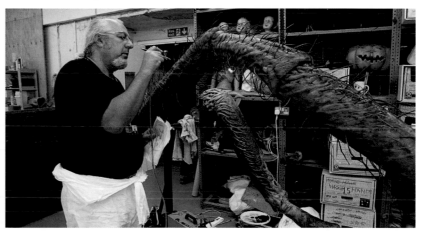

Fig 4.

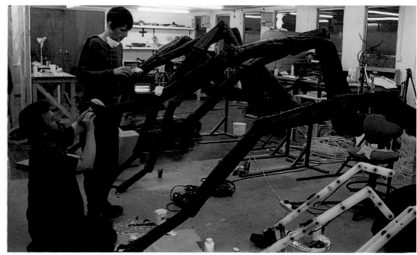

Fig 5.

Fig 1. (opposite) Harry Potter comes face to mandible with Aragog in artwork by
Dermot Power for *Harry Potter and the Chamber of Secrets*; Figs 2. — 5. In the creature
shop, designers build the animatronics, and paint, airbrush, and "hair" Aragog.

Hippogriff

The Hippogriff is an eagle-headed equine that can fly as well as gallop. As taught by Rubeus Hagrid, Care of Magical Creatures professor for third years in *Harry Potter and the Prisoner of Azkaban*, proper etiquette must be observed when meeting a Hippogriff: bow, and always wait for the creature to come to you.

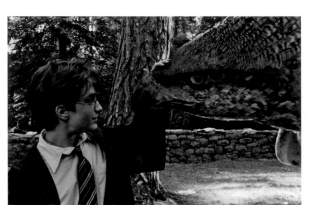

Fig 1.

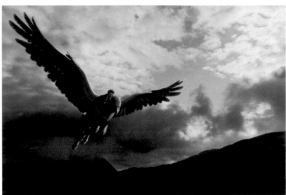

Fig 2.

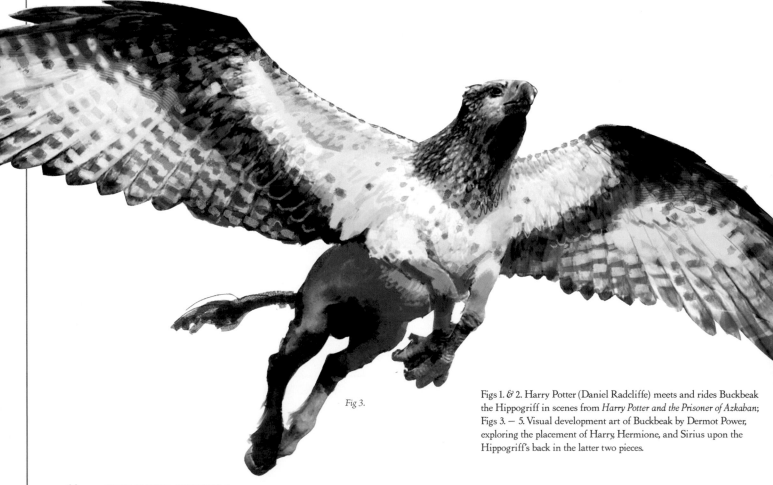

Fig 3.

Figs 1. & 2. Harry Potter (Daniel Radcliffe) meets and rides Buckbeak the Hippogriff in scenes from *Harry Potter and the Prisoner of Azkaban*; Figs 3. — 5. Visual development art of Buckbeak by Dermot Power, exploring the placement of Harry, Hermione, and Sirius upon the Hippogriff's back in the latter two pieces.

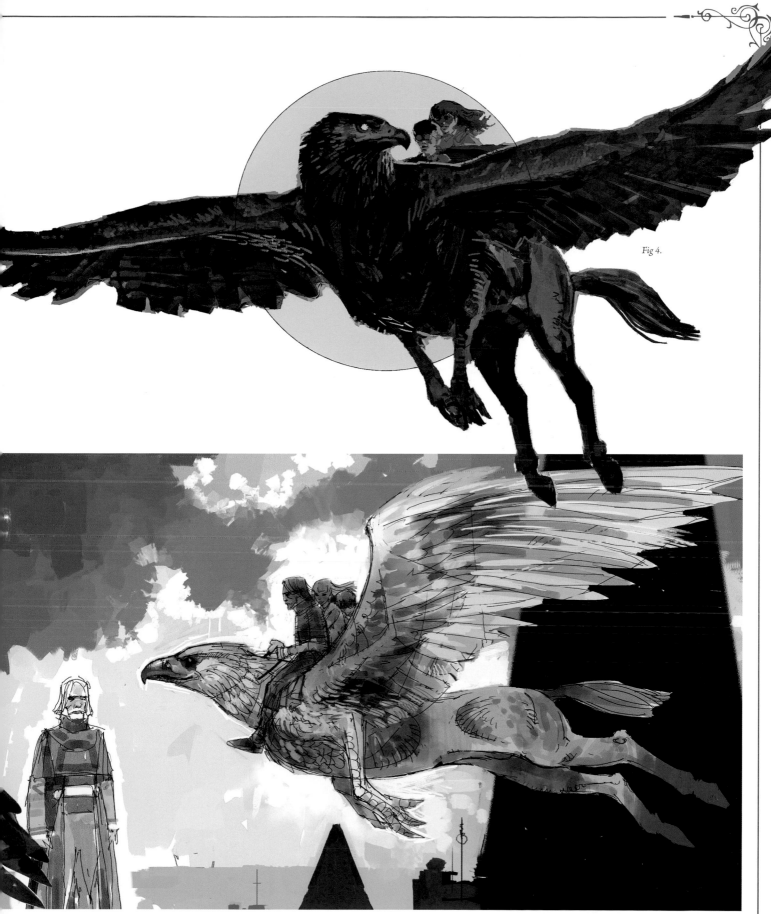

Fig 4.

Fig 5.

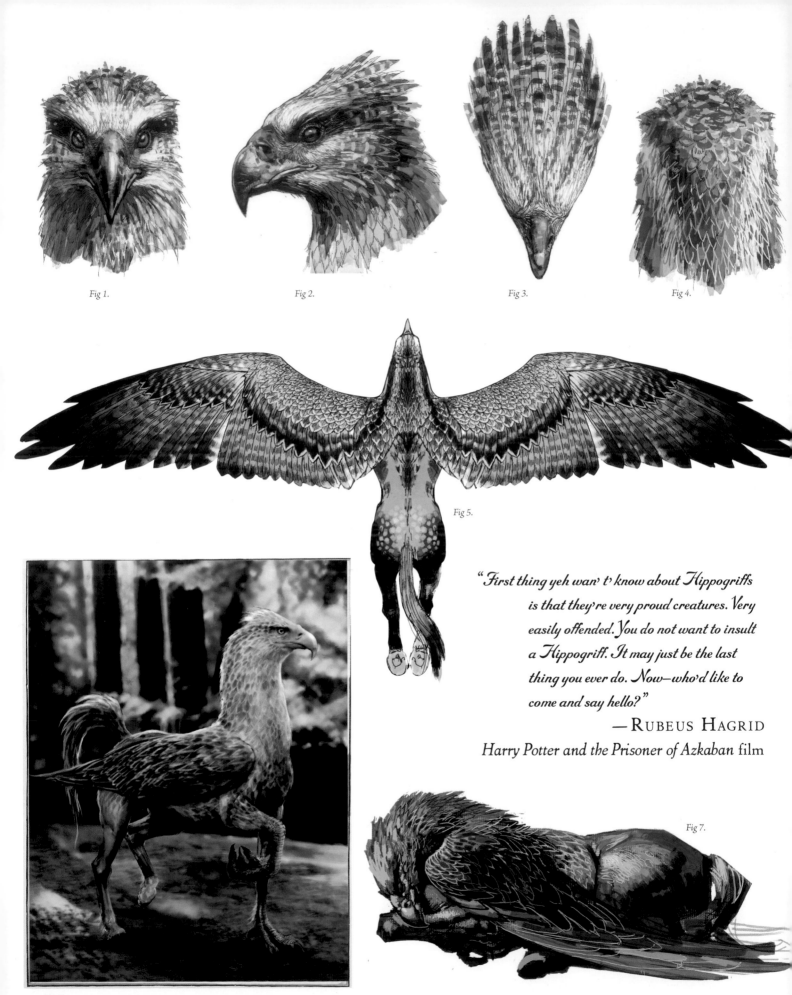

Fig 1.

Fig 2.

Fig 3.

Fig 4.

Fig 5.

Fig 6.

Fig 7.

"First thing yeh wan' t' know about Hippogriffs is that they're very proud creatures. Very easily offended. You do not want to insult a Hippogriff. It may just be the last thing you ever do. Now—who'd like to come and say hello?"

—RUBEUS HAGRID

Harry Potter and the Prisoner of Azkaban film

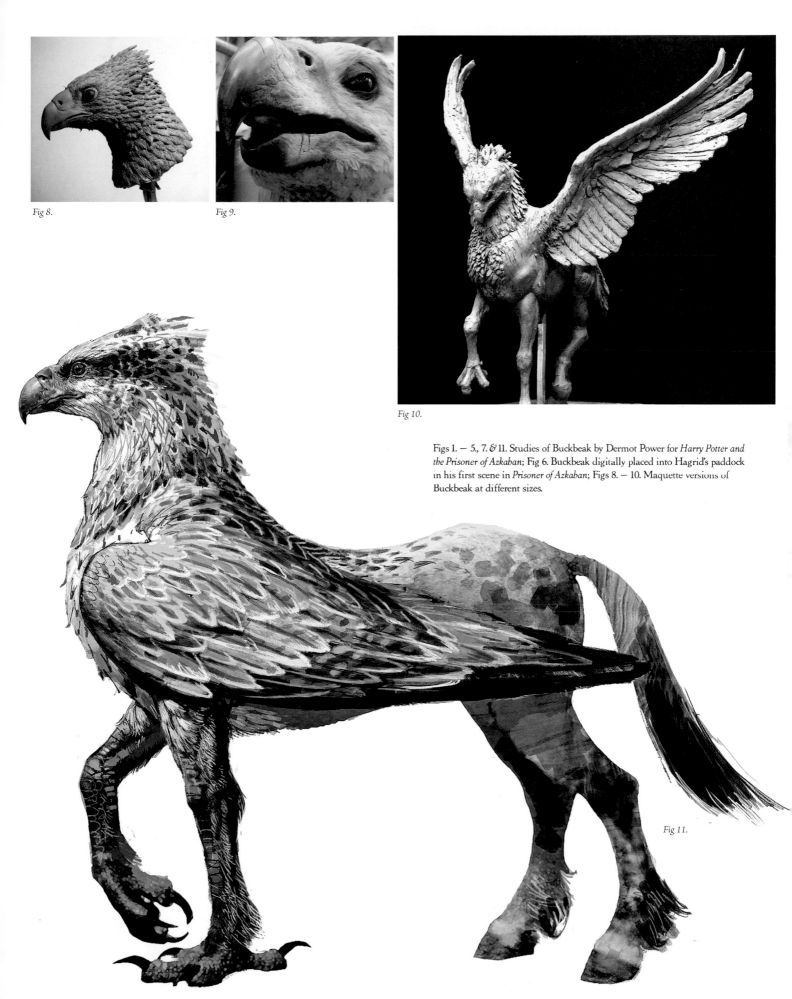

Fig 8.

Fig 9.

Fig 10.

Figs 1. — 5., 7. & 11. Studies of Buckbeak by Dermot Power for *Harry Potter and the Prisoner of Azkaban*; Fig 6. Buckbeak digitally placed into Hagrid's paddock in his first scene in *Prisoner of Azkaban*; Figs 8. — 10. Maquette versions of Buckbeak at different sizes.

Fig 11.

BUCKBEAK

Buckbeak, the Hippogriff that Hagrid introduces during his first Care of Magical Creatures class in *Harry Potter and the Prisoner of Azkaban,* needed to be able to bow to Harry, and even be ridden by him. Buckbeak is valuable to two rescue operations during the events of *Prisoner of Azkaban,* the first when Harry and Hermione are pursued by the werewolf form of Remus Lupin, and then again when Harry and Hermione save Sirius Black; Buckbeak flew Sirius away from Hogwarts castle.

The designers of Buckbeak drew upon the mythological representations of Hippogriffs when developing the creature for *Harry Potter and the Prisoner of Azkaban,* as well as real birds, primarily the golden eagle, for the creature's profile. To develop Buckbeak's movement, they studied the flight motion of birds and the gait of horses. They also consulted with veterinarians and physiologists to ensure that there was logic to the proportion of Buckbeak's wings to his legs.

Early development sketches were turned into computer-generated models to test all aspects of the creature's motion—galloping, flying, and, most important, landing. The CGI model was also used to explore Buckbeak's personality, which is alternately regal and coltish. One challenge accomplished by the visual effects team was to create smooth, uninterrupted movement as Buckbeak's wings went from a twenty-eight foot extended wingspan to fully folded wings.

Four models of the Hippogriff were constructed to satisfy different needs. Three were life-size: A digitally controlled standing Buckbeak on a counterbalanced pole arm was used for foreground shots, a freestanding Buckbeak was used for background shots, and the third was the condemned Buckbeak who sat in the pumpkin patch behind Hagrid's hut. The sitting Buckbeak was literally placed into his environment—a very muddy, rocky Scottish hillside—and controlled by Aquatronics. These three Hippogriffs needed to match exactly and utilized time- and labor-intensive construction methods. Their bird half was accomplished using the same sizes and colors of feathers for each version, with each feather cut, colored, and inserted or glued on individually. Their horse half had their hairs inserted by the complicated flocking process, like the method used for the centaurs, with additional hairs inserted one at a time. It was then airbrushed and art-worked. The fourth Buckbeak was created digitally and used whenever the animal needed to walk or fly.

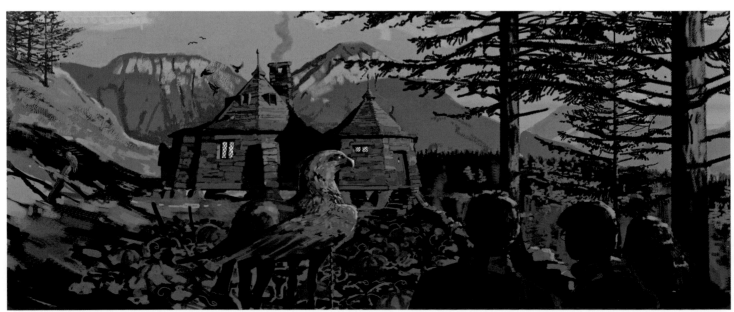

Fig 1.

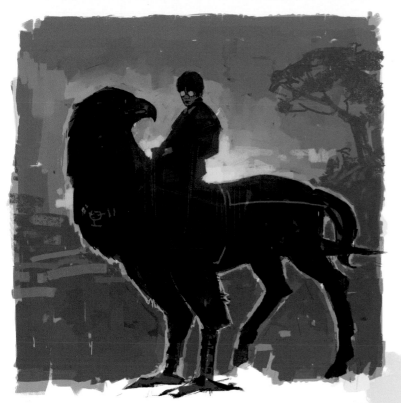
Fig 2.

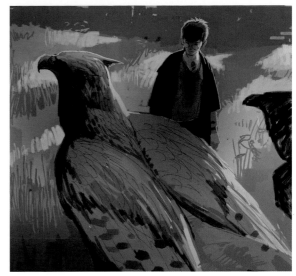
Fig 3.

Fig 1. Harry, Ron, and Hermione approach
Hagrid's hut to rescue Buckbeak, artwork
by Andrew Williamson; Fig 2. Artwork of
Harry atop Buckbeak by Dermot Power;
Fig 3. Harry among several Hippogriffs
by Dermot Power; Fig 4. Dermot Power
portrays Hagrid's introduction of
Buckbeak to Harry.

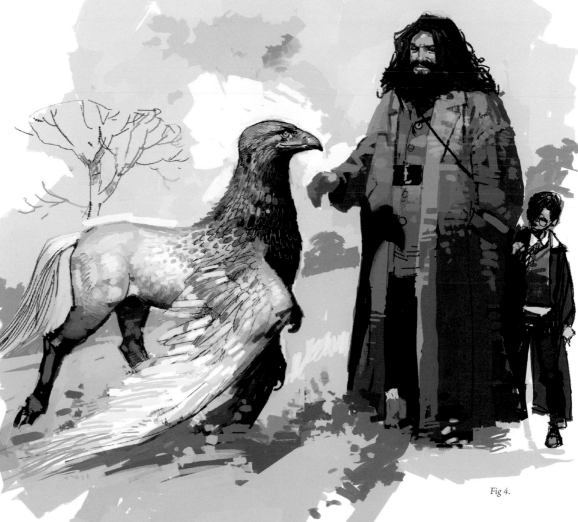
Fig 4.

Studies of Buckbeak with Sirius Black, Harry, and Hermione on his back (Figs 1. & 3.), and flying with Harry (Fig. 2), by Dermot Power for *Harry Potter and the Prisoner of Azkaban*.

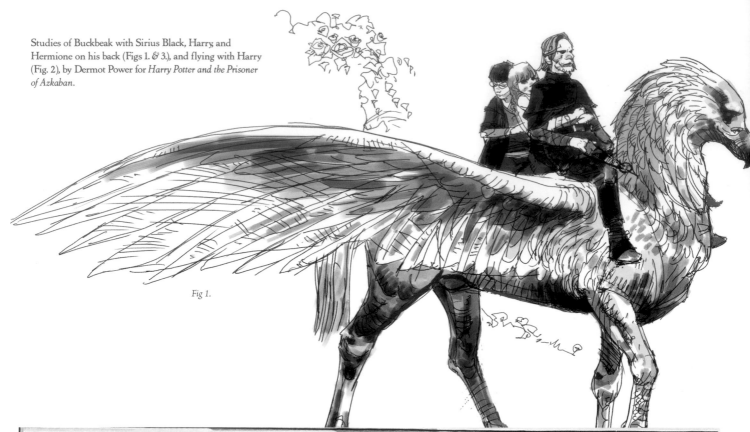

Fig 1.

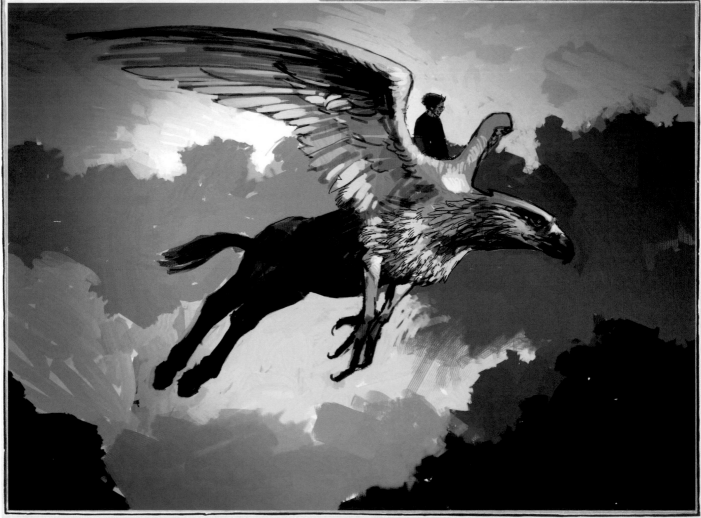

Fig 2.

FAST FACTS

BUCKBEAK

✴

I. FILM APPEARANCE: *Harry Potter and the Prisoner of Azkaban*

II. LOCATION: Hogwarts paddock

III. TECH TALK: The digital animators had Buckbeak take a "poo" just as he begins to walk toward the students, inspired by director Alsonso Cuarón's desire to add a "matter-of-fact" realism to the creatures.

IV: DESCRIPTION FROM *HARRY POTTER AND THE PRISONER OF AZKABAN* BOOK, CHAPTER SIX

"Once you got over the first shock of seeing something that was half horse, half bird, you started to appreciate the hippogriffs' gleaming coats, changing smoothly from feather to hair . . ."

"Isn't he beautiful?
Say hello to Buckbeak."
—RUBEUS HAGRID
Harry Potter and
the Prisoner of Azkaban film

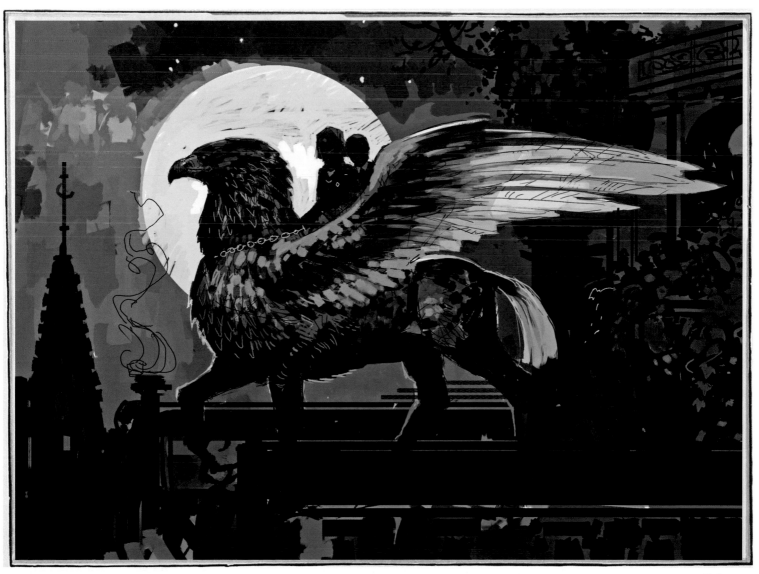

Fig 3.

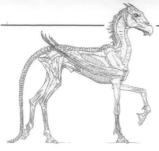 # Thestral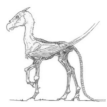

In the first four Harry Potter films, the carriages that shuttle between Hogsmeade Station and Hogwarts castle appear to be pulled by nothing, but in fact they are pulled by Thestrals, which did not need to be realized visually until *Harry Potter and the Order of the Phoenix*. It is only after the events of *Harry Potter and the Goblet of Fire* that Harry is able to see these black, skeletal, dragon-faced creatures, as Thestrals are visible only to those who have seen death.

Thestrals help transport Harry and other members of Dumbledore's Army to the Ministry of Magic during *Order of the Phoenix*. A Thestral ridden by Bill Weasley and his bride, Fleur Delacour, is also used as part of the plan to rescue Harry Potter from Privet Drive in *Harry Potter and the Deathly Hallows – Part 1*.

The Thestral, a creature unique to the world of Harry Potter, is depicted as having a delicate walk, a quiet cry similar to whale song, and translucent, bat-like wings, which enhance its mysterious, disturbing character. The Thestrals are computer-generated, but the creature shop created a full-scale model to ensure that its thirty-foot wingspan would fit into the Forbidden Forest set in *Harry Potter and the Order of the Phoenix*. This model was cyberscanned for the digital artists to utilize. As the Thestral is so emaciated, the computer animators created a detailed skeleton, with special care taken to ensure that the creature's thin skin didn't get "sucked" into its bones. The black coloring of the creature provided a challenge to the designers—a dark, gloomy black would not film well for the screen. It was determined that the model should be painted paler than assumed and have a mottled color scheme, giving the Thestral a moody radiance among the shadows of the forest set.

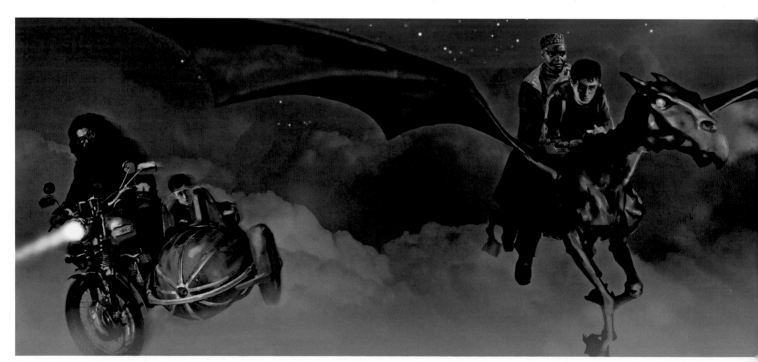

Fig 1.

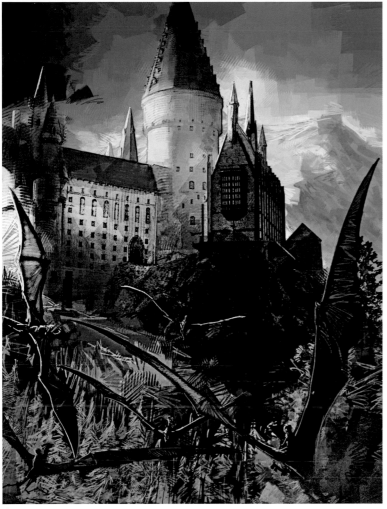

Fig 2.

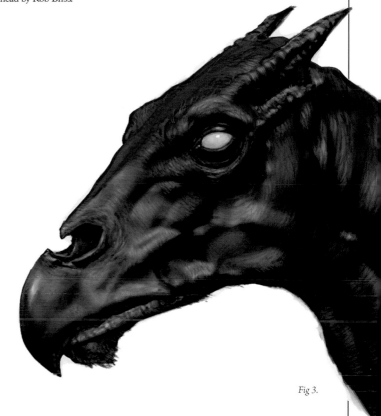

Fig 1. Andrew Williamson's artwork depicts multiple Harry Potters escaping from Privet Drive for *Harry Potter and the Deathly Hallows – Part 1*; Fig 2. The Thestrals, ridden by members of Dumbledore's Army in *Harry Potter and the Order of the Phoenix*, take to the skies in concept art by Rob Bliss; Figs 3. & 4. Studies of shadows and blacks on the Thestral head by Rob Bliss.

Fig 3.

At times, the Thestral's horselike anatomy worked against what was required in the script, specifically when Luna feeds the Thestral foal in the forest. Its long legs and short neck made it difficult for its head to reach the ground. The task was finally accomplished when the digital artists had the Thestral position its legs like a giraffe's in order to scoop up the treat.

Adjustments also needed to be implemented for Thestrals in flight. The creatures only carried one passenger each in *Order of the Phoenix*, but to accommodate two passengers in *Deathly Hallows – Part 1*, the Thestral's spine was elongated. The flight scenes were a composite of aerial cinematography and actors filmed riding a fully realized midsection of a Thestral in front of a blue screen. These sculpts had a jointed back and articulated movements that the actors could respond to. Placed on a pre-programmed motion-controlled gimbal, the Thestral model flew in unison with the filmed sequence.

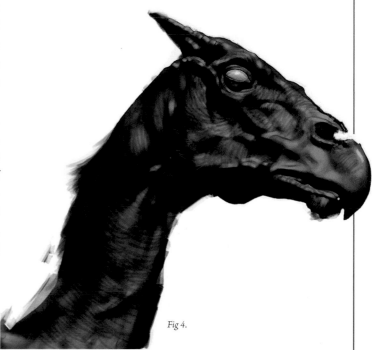

Fig 4.

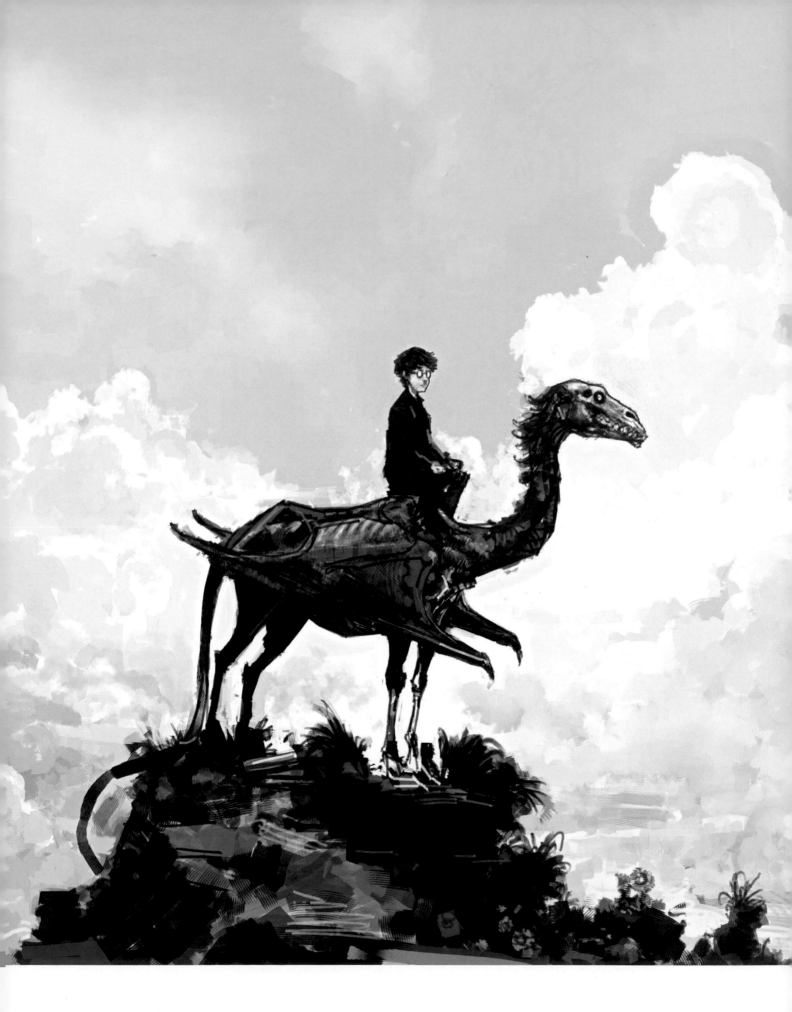

FAST FACTS

THESTRAL

✴

I. FIRST FILM APPEARANCE: *Harry Potter and the Order of the Phoenix*

II. ADDITIONAL FILM APPEARANCE:
Harry Potter and the Deathly Hallows – Part 1

III. LOCATION: Hogsmeade Station, Forbidden Forest

IV: DESIGN NOTE: The designers had the Thestrals flick flies away from their bodies with their tails, just like horses.

V: DESCRIPTION FROM *HARRY POTTER AND THE ORDER OF THE PHOENIX* BOOK, CHAPTER TEN:
"Wings sprouted from each wither—vast, black leathery wings that looked as though they ought to belong to giant bats. Standing still and quiet in the gloom, the creatures looked eerie and sinister."

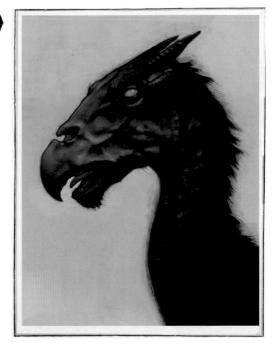

Fig 2.

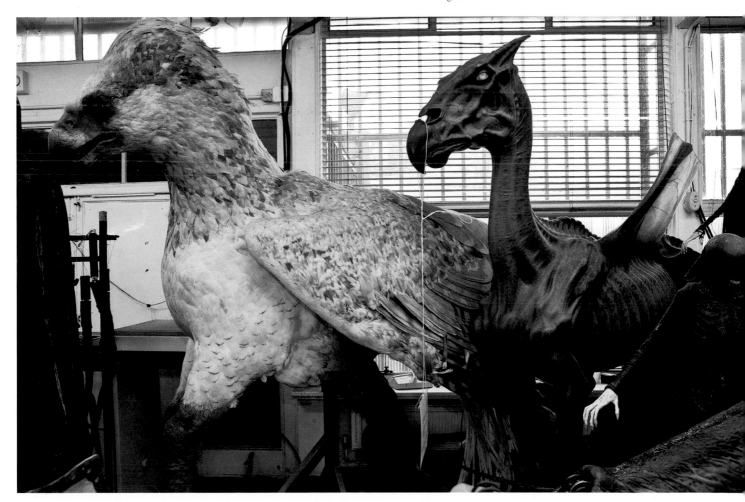

Fig 1. (opposite) Harry Potter sits a bit awkwardly atop a Thestral in artwork by Rob Bliss for *Harry Potter and the Order of the Phoenix*; Fig 2. Rob Bliss Thestral head study; Fig 3. (above) In the creature shop, the maquettes of Buckbeak, a Thestral, and a Dementor stand side by side.

CHAPTER II

LAKE DWELLERS

*In the Harry Potter films, Hogwarts castle perches on a cliff beside
the great Black Lake, which is the location for the second task
of the Triwizard Tournament in Harry Potter and the Goblet
of Fire. Inhabitants of the Black Lake include the merpeople, a
blend of human and fish, whose speech is only understandable
underwater. The champions of the tournament also encounter
another resident community of the lake, the impish Grindylows.*

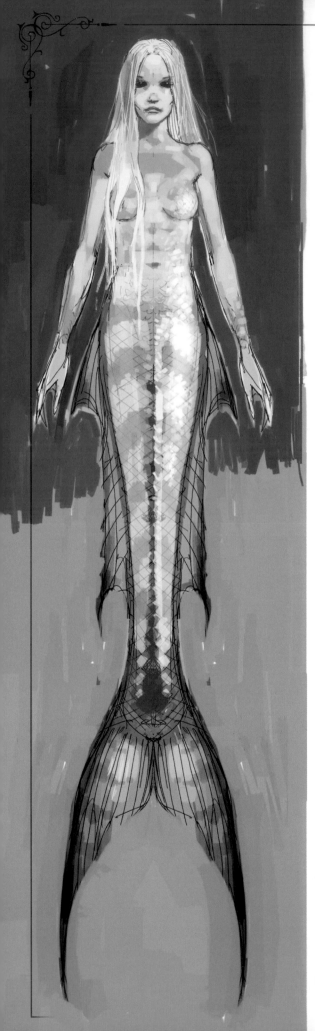

Merperson

Wielding tridents, the merpeople of the Black Lake monitor the Triwizard champions in a forest of kelp and coral-encrusted architecture to ensure that the students follow the parameters of their mission for the second task of the Triwizard Tournament.

In traditional folklore and artwork of mermaids, there is a noticeable break between their human and fish halves. But for the merpeople in *Harry Potter and the Goblet of Fire*, the designers distributed the fishiness throughout the being's anatomy to craft a composite creature. This seamless combination morphs a human and, specifically, a sturgeon, with large, fishlike eyes and a bulging mouth. Other breaks with convention were having the merperson's tail move from side to side instead of up and down, and adding dorsal and pelvic fins for stability. Their scaly skin even imitates the bony scutes of a sturgeon, shield-like plates that appear in parallel rows down the body. The designers chose a dark, muddy color palette to emphasize the merpeople's menacing personality. Once the design was finalized, it was sculpted, molded, and then cyberscanned to become computer-generated creatures.

Page 32: A two-legged Grindylow prepares to eat a tasty meal among the kelp leaves of the Black Lake in concept artwork by Paul Catling for *Harry Potter and the Goblet of Fire*; Fig 1. An early concept drawing of a merperson by Dermot Power for *Harry Potter and the Goblet of Fire*; Fig 2. Adam Brockbank artwork portrays a merperson with octopus-like hair.

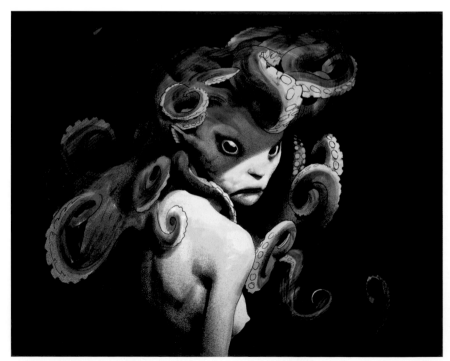

Fig 2.

Fig 1.

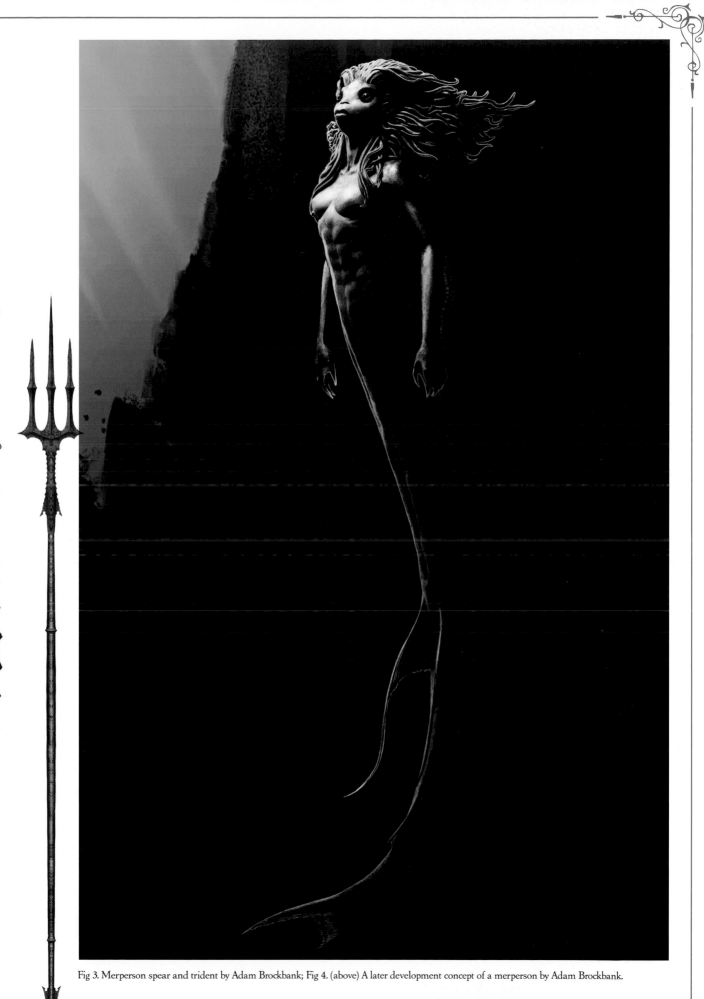

Fig 3. Merperson spear and trident by Adam Brockbank; Fig 4. (above) A later development concept of a merperson by Adam Brockbank.

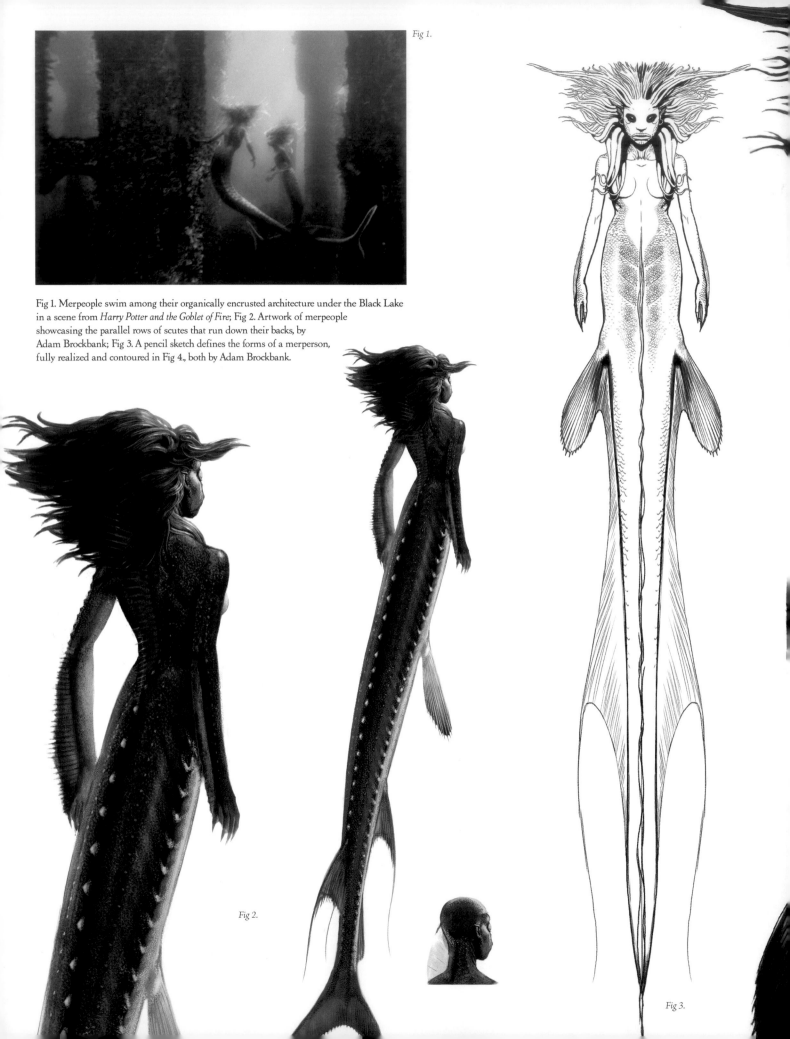

Fig 1.

Fig 1. Merpeople swim among their organically encrusted architecture under the Black Lake in a scene from *Harry Potter and the Goblet of Fire*; Fig 2. Artwork of merpeople showcasing the parallel rows of scutes that run down their backs, by Adam Brockbank; Fig 3. A pencil sketch defines the forms of a merperson, fully realized and contoured in Fig 4., both by Adam Brockbank.

Fig 2.

Fig 3.

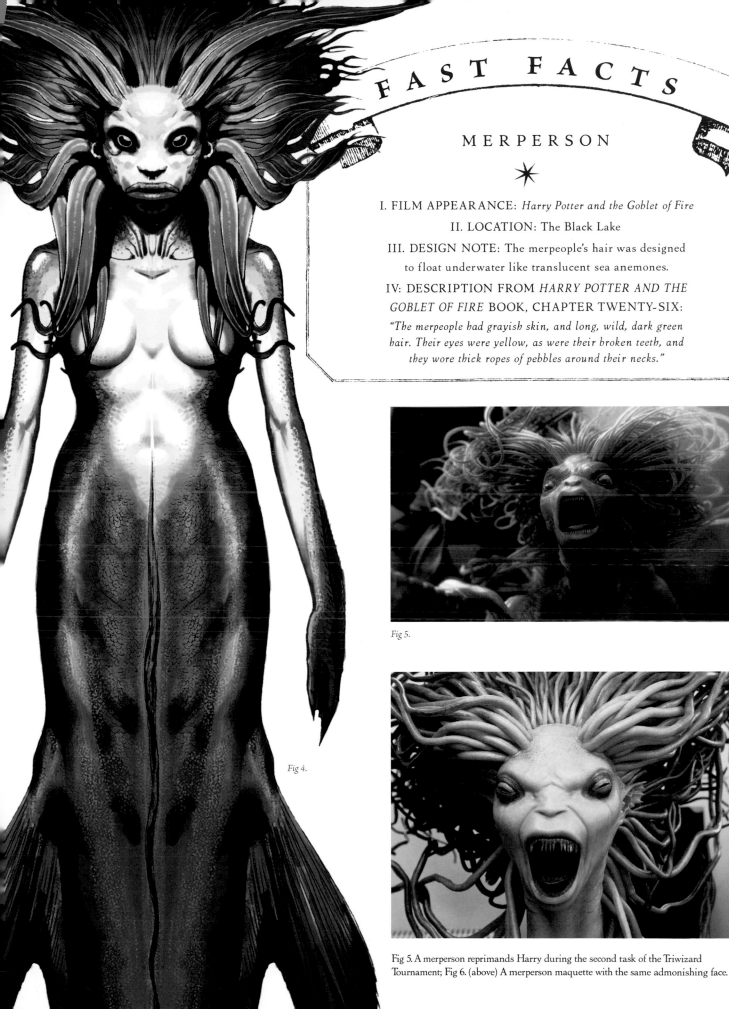

MERPERSON

✳

I. FILM APPEARANCE: *Harry Potter and the Goblet of Fire*

II. LOCATION: The Black Lake

III. DESIGN NOTE: The merpeople's hair was designed to float underwater like translucent sea anemones.

IV: DESCRIPTION FROM *HARRY POTTER AND THE GOBLET OF FIRE* BOOK, CHAPTER TWENTY-SIX:

"The merpeople had grayish skin, and long, wild, dark green hair. Their eyes were yellow, as were their broken teeth, and they wore thick ropes of pebbles around their necks."

Fig 4.

Fig 5.

Fig 5. A merperson reprimands Harry during the second task of the Triwizard Tournament; Fig 6. (above) A merperson maquette with the same admonishing face.

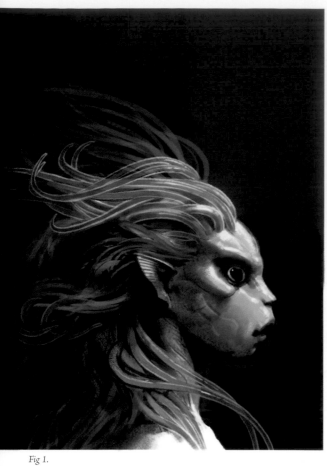

Fig 1.

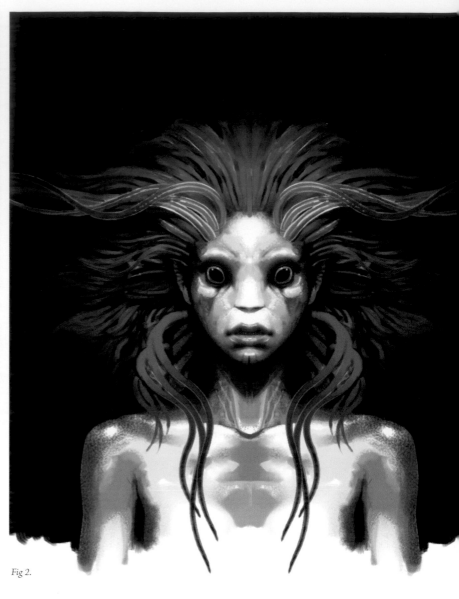

Fig 2.

"*Come seek us where our voices sound,*
we cannot sing above the ground.
An hour long you'll have to look
to recover what we took."
— MERPEOPLE'S CLUE
FOR THE SECOND TASK
OF THE TRIWIZARD
TOURNAMENT
Harry Potter and the Goblet of Fire film

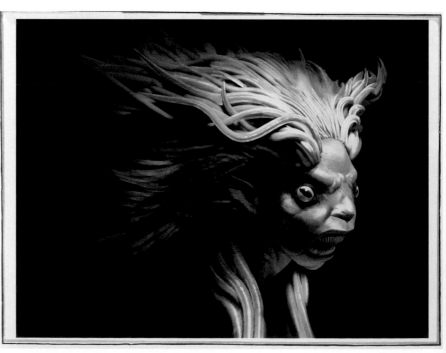

Fig 3.

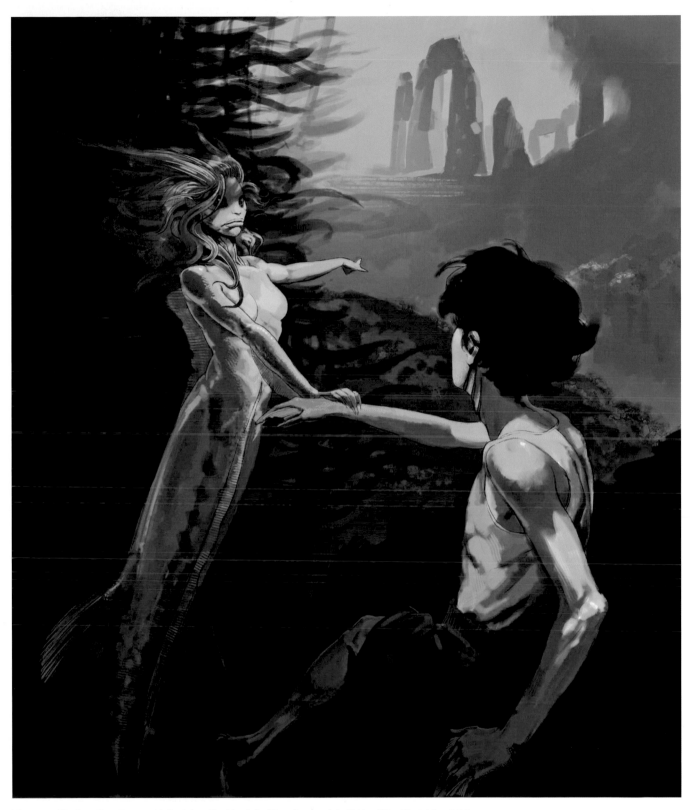

Figs 1. — 3. Head studies of merpeople by Adam Brockbank for *Harry Potter and the Goblet of Fire*; Fig 4. (above) Adam Brockbank's depiction of a merperson helping Harry during the second task of the Triwizard Tournament, a circumstance that did not actually occur in *Goblet of Fire*.

Grindylow

In the Harry Potter films, Grindylows are unfriendly little creatures, with short octopus-like arms and bulbous, tentacled heads, that live in the Black Lake. Harry Potter narrowly escapes their grasp in *Harry Potter and the Goblet of Fire* during the second task of the Triwizard Tournament.

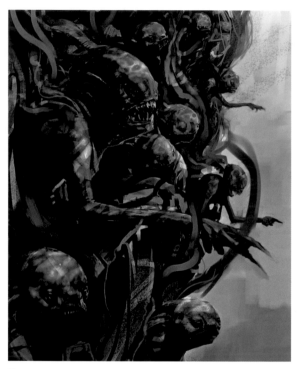

Fig 1.

When given the task of bringing the Grindylows to life on-screen in *Harry Potter and the Goblet of Fire*, the visual development artists came up with many different versions of what this underwater creature could be. Grindylows were designed with small heads, two legs, two webbed feet, eight webbed hands, huge glowing eyes, and large pointed ears. Several were luminescent, similar to fish that live in the darkest corners of the deep sea. Some bodies were shaped to resemble frogs, others were seal-like, and several had their own version of a mermaid's tale. With all these ideas in the mix, a design was chosen based on what Grindylows needed to do physically. That's when the creature shop produced a design they described as a cross between "a nasty child and an octopus," complete with a significantly large grinning mouth filled with sharp teeth. As was done with so many of the other creatures in the Harry Potter film series, full-size silicone maquettes were created and painted, then cast again as fiberglass models to be cyberscanned for the CGI artists to animate. Additionally, new software was developed by the visual effects team to handle the large number of Grindylows in a simplified way.

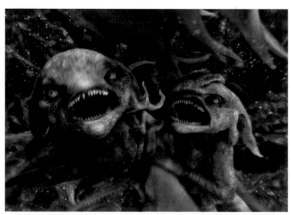

Fig 2.

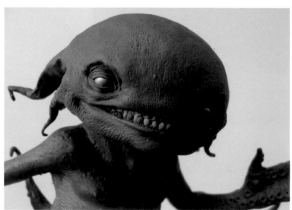

Fig 3.

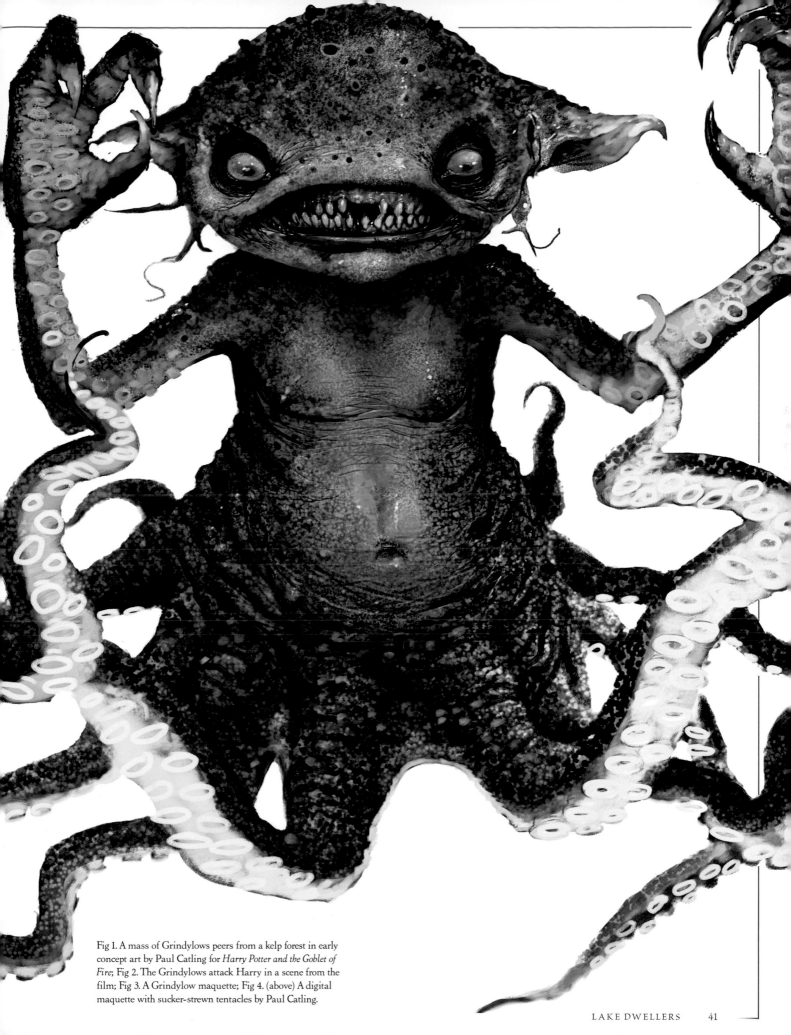

Fig 1. A mass of Grindylows peers from a kelp forest in early concept art by Paul Catling for *Harry Potter and the Goblet of Fire*; Fig 2. The Grindylows attack Harry in a scene from the film; Fig 3. A Grindylow maquette; Fig 4. (above) A digital maquette with sucker-strewn tentacles by Paul Catling.

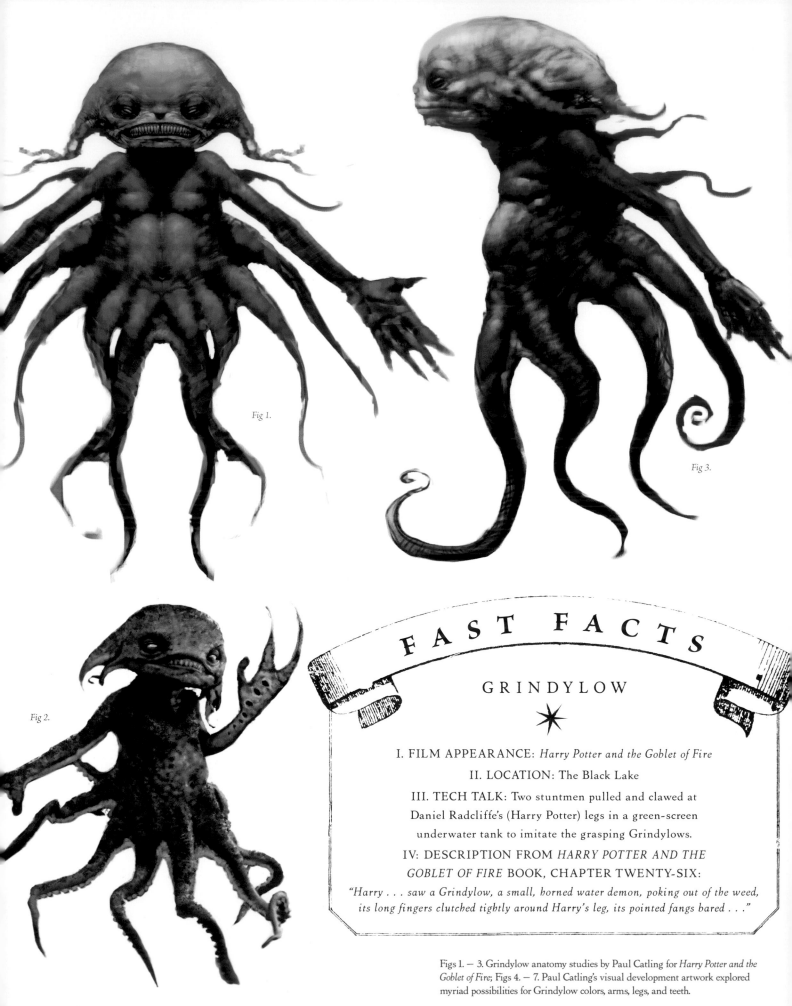

Fig 1.

Fig 3.

Fig 2.

GRINDYLOW

✶

I. FILM APPEARANCE: *Harry Potter and the Goblet of Fire*

II. LOCATION: The Black Lake

III. TECH TALK: Two stuntmen pulled and clawed at
Daniel Radcliffe's (Harry Potter) legs in a green-screen
underwater tank to imitate the grasping Grindylows.

IV: DESCRIPTION FROM *HARRY POTTER AND THE
GOBLET OF FIRE* BOOK, CHAPTER TWENTY-SIX:

*"Harry . . . saw a Grindylow, a small, horned water demon, poking out of the weed,
its long fingers clutched tightly around Harry's leg, its pointed fangs bared . . ."*

Figs 1. — 3. Grindylow anatomy studies by Paul Catling for *Harry Potter and the
Goblet of Fire*; Figs 4. — 7. Paul Catling's visual development artwork explored
myriad possibilities for Grindylow colors, arms, legs, and teeth.

Fig 4.

Fig 5.

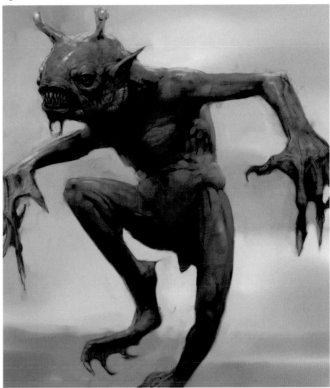

Fig 6.

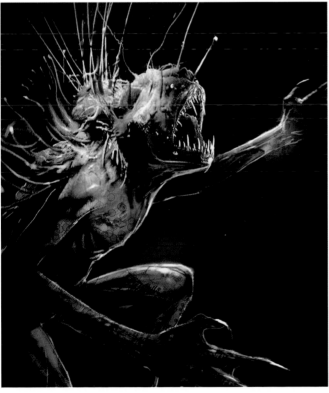

Fig 7.

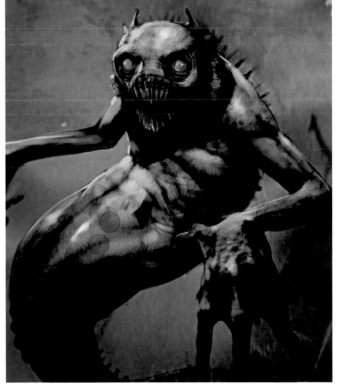

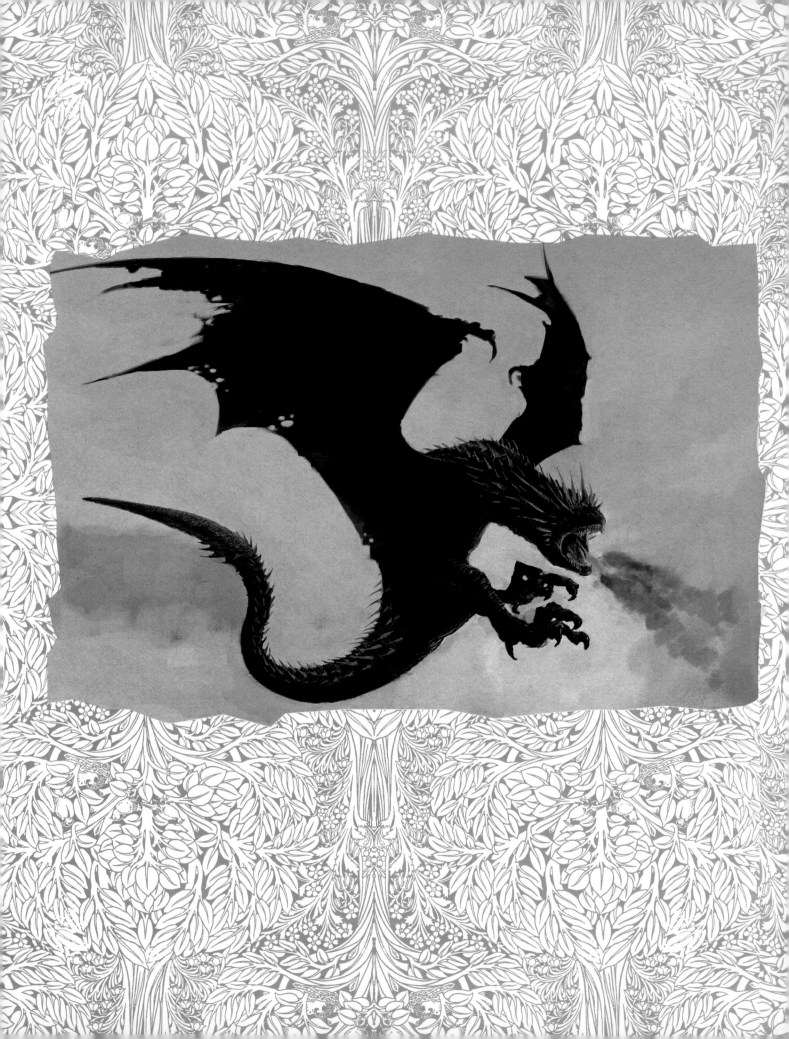

CHAPTER III

SKY DWELLERS

Owls and crows, among other creatures, including Hippogriffs and Thestrals, fly in the blue skies above Hogwarts castle throughout the Harry Potter films. But there have been times when additional flying creatures—large and small—have been brought onto the school grounds. Cornish pixies were released in the Defense Against the Dark Arts classroom for a teaching demonstration that didn't turn out exactly as planned. And dragons soared above and around the arena built for the first task of the Triwizard Tournament, in a clash with four champions.

Dragon

Throughout the Harry Potter films, one of the most thrilling of the flying creatures is the fire-breathing dragon, and the filmmakers were offered several opportunities to portray these powerful reptilian creatures using time-honored and new techniques. Hagrid's dream of fostering a dragon comes true, albeit for a short time. Four powerful dragons are used in the first task of the Triwizard Tournament. And Gringotts Wizarding Bank employs an old but powerful dragon to guard its deepest vaults.

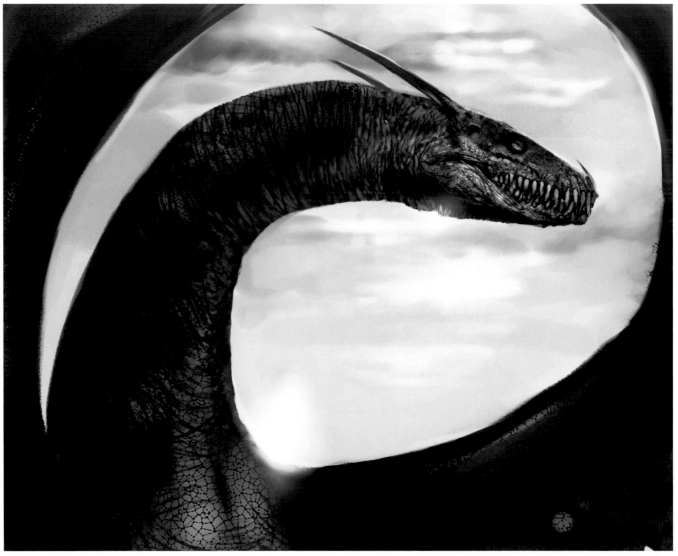

Fig 1.

Page 44: The fire-breathing Hungarian Horntail by Paul Catling for *Harry Potter and the Goblet of Fire*; Figs 1. & 2. Visual development art by Paul Catling of unidentified dragons for *Harry Potter and the Goblet of Fire*.

"Dragons are seriously misunderstood creatures."
— RUBEUS HAGRID
Harry Potter and the Goblet of Fire film

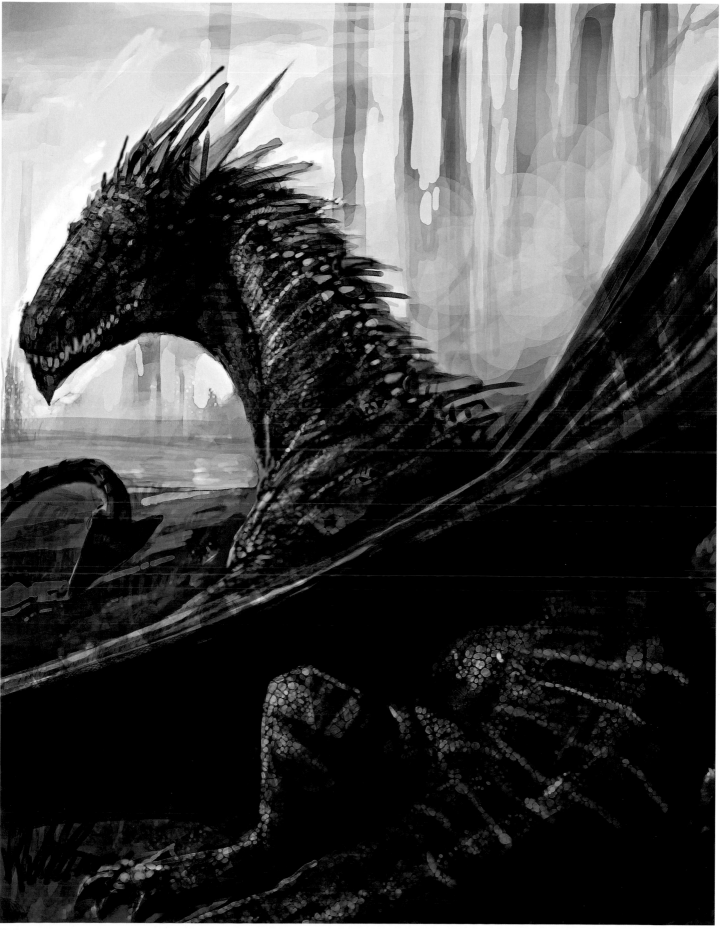

Fig 2.

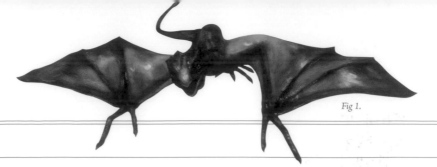

Fig 1.

NORWEGIAN RIDGEBACK

In *Harry Potter and the Sorcerer's Stone*, Hagrid wins a dragon egg, which hatches into a wobbly-legged, shiny, grayish-green, drooling baby Norwegian Ridgeback dragon. Dragons are usually built on the larger side of the scale, but Norbert is newly hatched, so the designers needed to work on the smaller side. The filmmakers decided that at this stage, the ridge in "Ridgeback" wouldn't be quite developed, and in the film the infant dragon's head and legs are larger in proportion to its body than those of the more mature dragons that they created. In *Harry Potter and the Sorcerer's Stone*, Norbert is a completely digital construction, as is the fire that singes Hagrid's beard when the dragonet hiccups out his first flame.

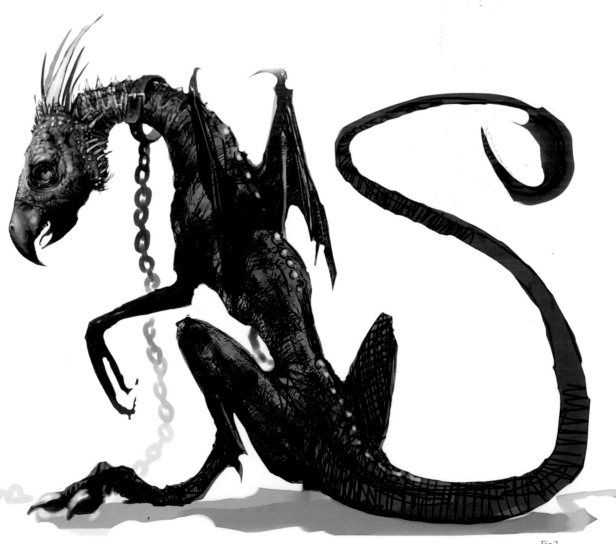

Fig 2.

*"Isn't he beautiful? Oh, bless 'im, look,
he knows 'is mummy. Hallo, Norbert."*
— RUBEUS HAGRID
Harry Potter and the Sorcerer's Stone film

Fig 3.

FAST FACTS

NORWEGIAN RIDGEBACK

✶

I. FILM APPEARANCE: *Harry Potter and the Sorcerer's Stone*

II. LOCATION: Hagrid's hut

III. DESCRIPTION FROM *HARRY POTTER AND THE SORCERER'S STONE* BOOK, CHAPTER FOURTEEN:

"It wasn't exactly pretty; Harry thought it looked like a crumpled, black umbrella. Its spiny wings were huge compared to its skinny jet body, and it had a long snout with wide nostrils, the stubs of horns, and bulging, orange eyes."

Fig 1. Norwegian Ridgeback concept art for *Harry Potter and the Sorcerer's Stone*; Figs 2. & 3. Paul Catling portrays the fledgling Norwegian Ridgeback Norbert's awkward gawkiness; Fig 4. Harry (Daniel Radcliffe) and Ron (Rupert Grint) witness Norbert's hatching in a scene from *Sorcerer's Stone.*

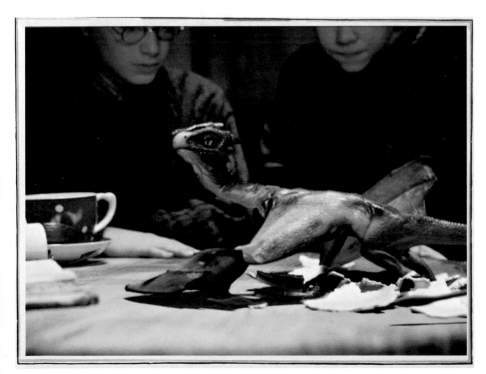

*"That's not just a dragon.
That's a Norwegian Ridgeback!"*
— RON WEASLEY
Harry Potter and the Sorcerer's Stone film

Fig 4.

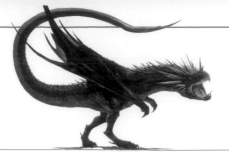

HUNGARIAN HORNTAIL

The first task of the Triwizard Tournament in *Harry Potter and the Goblet of Fire* requires the champions to retrieve one of four golden eggs guarded by different breeds of dragon. The concept artists explored innumerable colors, textures, profiles, and wing and tail forms to realize the variety of dragons to be seen on-screen. Harry is the last champion to draw the miniature representation of the dragon he will fight from the velvet bag Ministry supervisor Bartemius Crouch, Sr., holds, and it is none other than the Hungarian Horntail. The dragon model of the Horntail shows up again in *Harry Potter and the Half-Blood Prince*, where it is being used to roast chestnuts on a cart outside of Weasleys' Wizard Wheezes in Diagon Alley.

Aware of the legacy of dragons in mythology and media, the creative team on *Harry Potter and the Goblet of Fire* admitted their challenge was not *what* to do but what *not* to do when creating the dragons of the Triwizard Tournament—not have their dragons look like others that had come before. Visual development artists offered a dragon's horde of choices. Options included dragons with rows of large teeth, no teeth at all, or teeth like a walrus's. Some designs took their cue from recognizable animals: Dragons had the heads of rhinos, snakes, lizards, tortoises, and even a Doberman dog. For the dragon that Harry Potter would draw, they had some specific direction concerning the name of the creature: Hungarian Horntail.

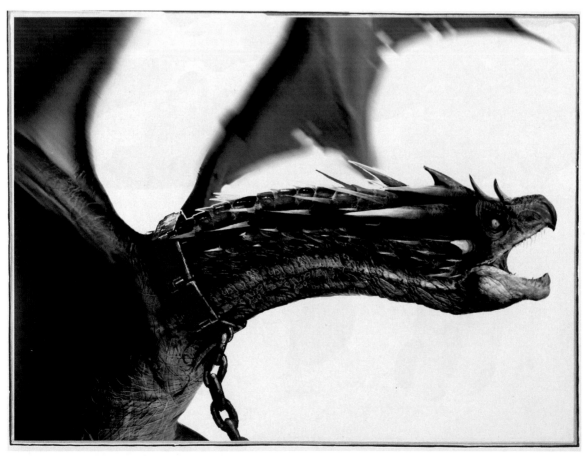

Fig 1.

Fig 1. Visual development art of the Hungarian Horntail by Adam Brockbank; Fig 2. A scale version maquette of the Hungarian Horntail; Fig 3. Caged prior to the first task, the Hungarian Horntail shoots a stream of fire out of the bars in a scene from *Goblet of Fire*; Fig 4. The fully realized, fire-breathing Hungarian Horntail head sits beside the Basilisk in the creature shop

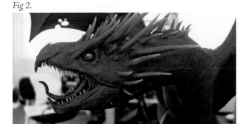

Fig 2.

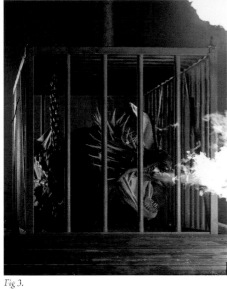

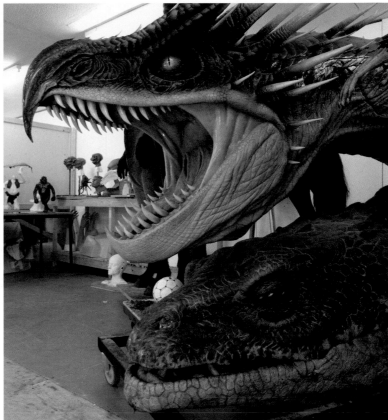

Fig 3.

Fig 4.

Initial approaches to the "horntail" part of the dragon included a tail resembling a scorpion's, a tail with one long spike, a tail with rows of spikes, and a tail with a cluster of spikes at its end. The final design gave the Horntail a blunt, hawklike head, huge taloned wings, two heavily clawed legs, and a ruff of spikes running down to her tail, which ends in a spear-shaped spike covered in smaller spikes.

The Horntail's movements were taken from those of predatory birds—falcons, hawks, and eagles. Her wings could be animated in concert or independently, she could "walk" across the Hogwarts castle roofs, and even hang with her wings folded like a bat.

The creature department created a fully painted fiberglass maquette of the Horntail at half scale—thirty feet long with a fourteen-foot wingspan—that was used for cyberscanning. They were then asked to build a bigger model, and so they built the head of the Horntail at full scale, which was used for lighting references and sight lines. Then they were asked to build the actual creature, to be used in the scene where Harry sees the caged dragons in the Forbidden Forest. The crew not only constructed a moving, threatening dragon, they also made it breathe fire.

Parts of the Basilisk from *Harry Potter and the Chamber of Secrets* were recycled to build a dragon's body that would fit inside the cage. The Horntail's actions were controlled by puppeteers who flapped the creature's wings and shook the cage's bars. The final dragon was nearly forty feet long, stood seven feet tall at the shoulder, and had an extended wingspan of seventy feet.

The skin of the Horntail was crafted in polyurethane, and the spikes were resin. Six sizes of spikes were molded, with many of them cracked or bent or broken, as the film's producers imagined that this dragon would have already had a long life of fighting. Her wings were aged and torn up to give her even more history. The special effects department was asked to install a flamethrower device, so a new head was recast in fiberglass, painted, and spiked, with its snout coated in Nomex, which made it fireproof. The dragon fire could reach up to thirty feet, so computer-controlled performance machinery was added to insure the movement and fire blasts were accurate and safe. The Horntail's beak was crafted in steel and glowed red when the fire passed by it—an unexpected design perk.

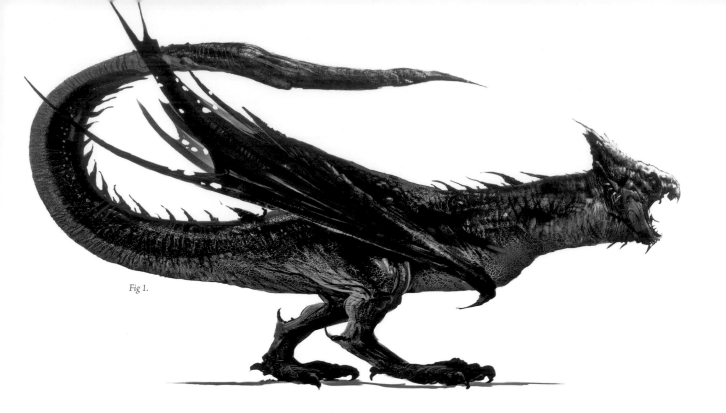

Fig 1.

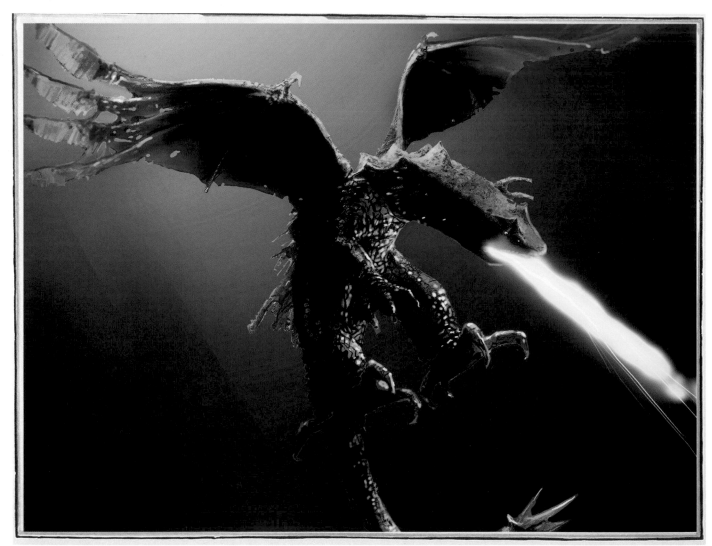

Fig 2.

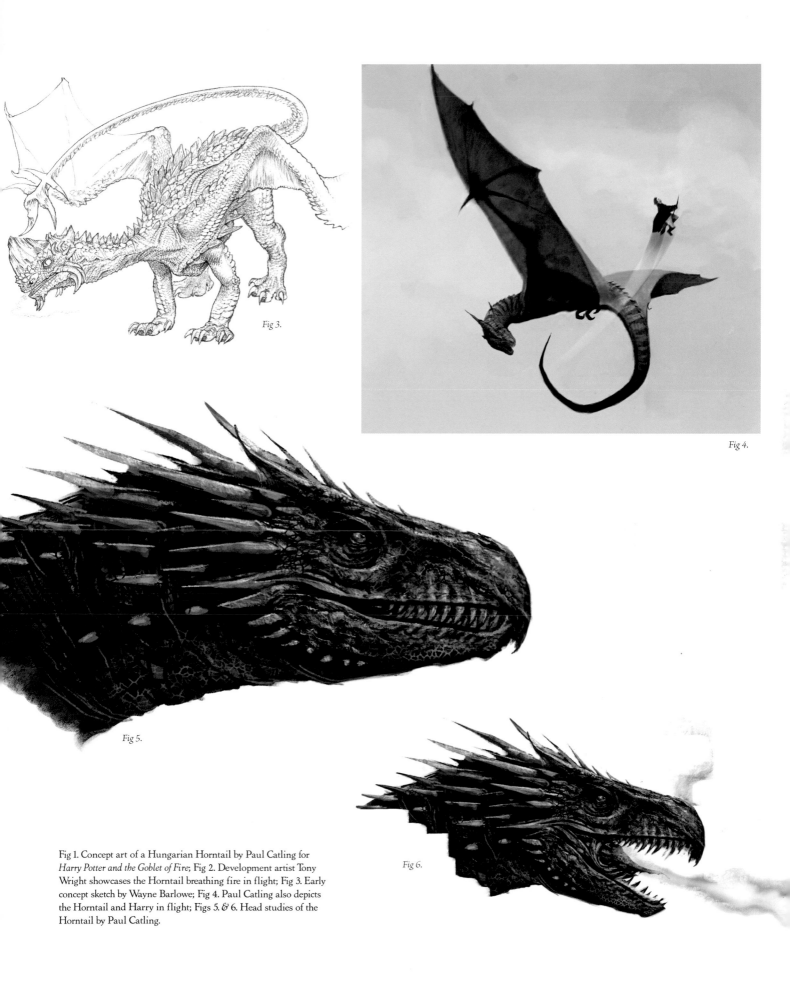

Fig 1. Concept art of a Hungarian Horntail by Paul Catling for *Harry Potter and the Goblet of Fire*; Fig 2. Development artist Tony Wright showcases the Horntail breathing fire in flight; Fig 3. Early concept sketch by Wayne Barlowe; Fig 4. Paul Catling also depicts the Horntail and Harry in flight; Figs 5. & 6. Head studies of the Horntail by Paul Catling.

Fig 3.

Fig 4.

Fig 5.

Fig 6.

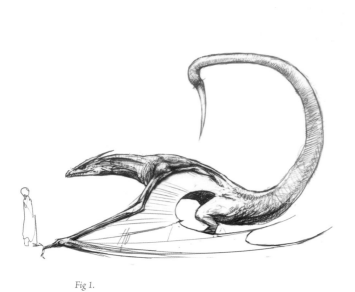

Fig 1.

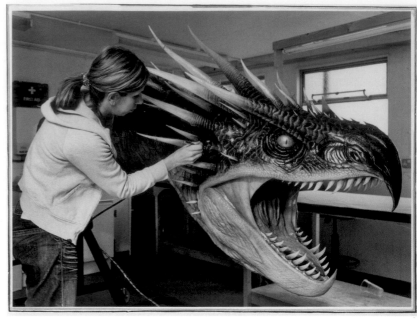

Fig 4.

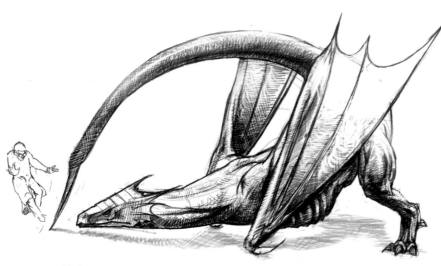

Fig 2.

*" I have to admit, that Horntail is
a right nasty piece of work."*

—RUBEUS HAGRID
Harry Potter and the Goblet of Fire film

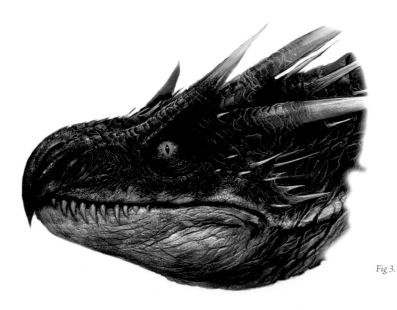

Fig 3.

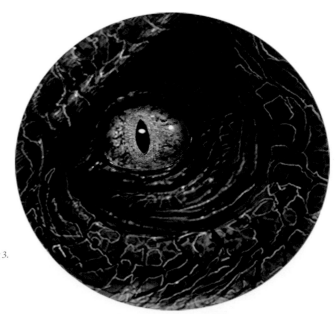

FAST FACTS

HUNGARIAN HORNTAIL

✷

I. FILM APPEARANCE: *Harry Potter and the Goblet of Fire*

II. ADDITIONAL FILM APPEARANCE

(MODEL ONLY): *Harry Potter and the Half-Blood Prince*

III. LOCATION: Triwizard Tournament arena (*the model also appeared in Diagon Alley, outside Weasleys' Wizard Wheezes*)

IV. TECH TALK: Pre-made poses of the Horntail were created in the computer to make the animation process of getting from pose A to pose B more efficient.

V. DESCRIPTION FROM *HARRY POTTER AND THE GOBLET OF FIRE* BOOK, CHAPTER TWENTY:

"And there was the Horntail . . . her wings half furled, her evil, yellow eyes upon him, a monstrous, scaly black lizard, thrashing her spiked tail . . ."

Figs 1. & 2. Early pencil studies by Wayne Barlowe; Fig 3. Paul Catling produced several studies of the Horntail's eye; Fig 4. Sculptor Kate Hill works on the Hungarian Horntail's spikes in the creature shop during a construction phase for *Harry Potter and the Goblet of Fire*; Paul Catling also portrayed a sleeked-down side view of the Horntail (Fig 5.) and a painting of wizards trying to control an uncaged Horntail in the Forbidden Forest (Fig 6.).

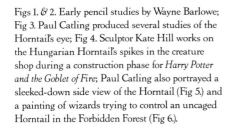

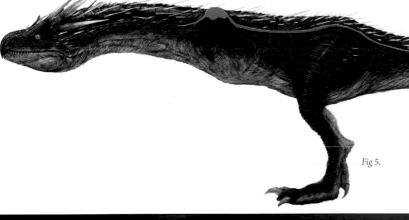

Fig 5.

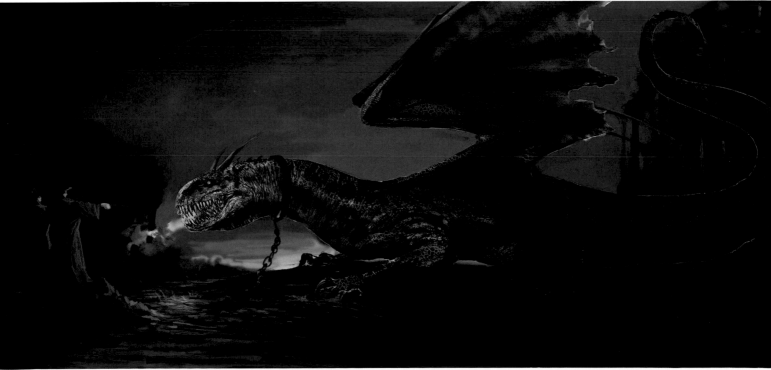

Fig 6.

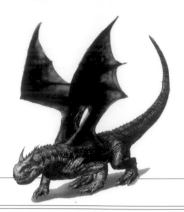

COMMON WELSH GREEN

Fleur Delacour from Beauxbatons Academy of Magic selects the Common Welsh Green, a dragon native to the United Kingdom, for the first task of the Triwizard Tournament. Concept artist Paul Catling's artwork carefully explores the textures and details of the Common Welsh Green that were realized in its miniature version on the big screen.

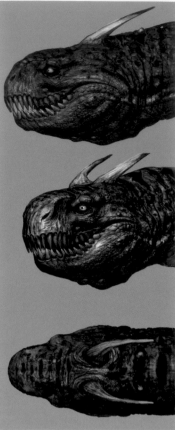

Figs 2.– 4.

Fig 1.

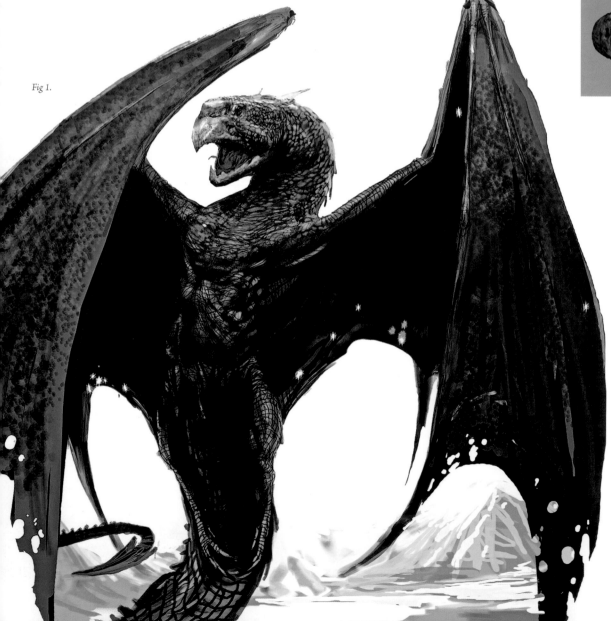

FAST FACTS

COMMON WELSH GREEN

I. FILM APPEARANCE: *Harry Potter and the Goblet of Fire*

II. LOCATION: Triwizard Tournament arena

III. DESCRIPTION FROM *HARRY POTTER AND THE GOBLET OF FIRE* BOOK, CHAPTER NINETEEN:

"There was . . . a smooth-scaled green one, which was writhing and stamping with all its might . . ."

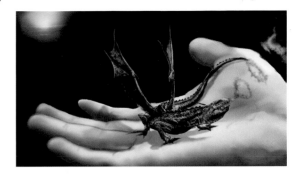

Fig 5.

Fig 1. Paul Catling depicts a Common Welsh Green with battle-scarred wings; Figs 2. — 4. Face and texture studies by Paul Catling; Fig 5. A close-up of the miniature Welsh Green in Fleur Delacour's hand by Paul Catling; Fig 6. Wing studies of the Welsh Green by Paul Catling.

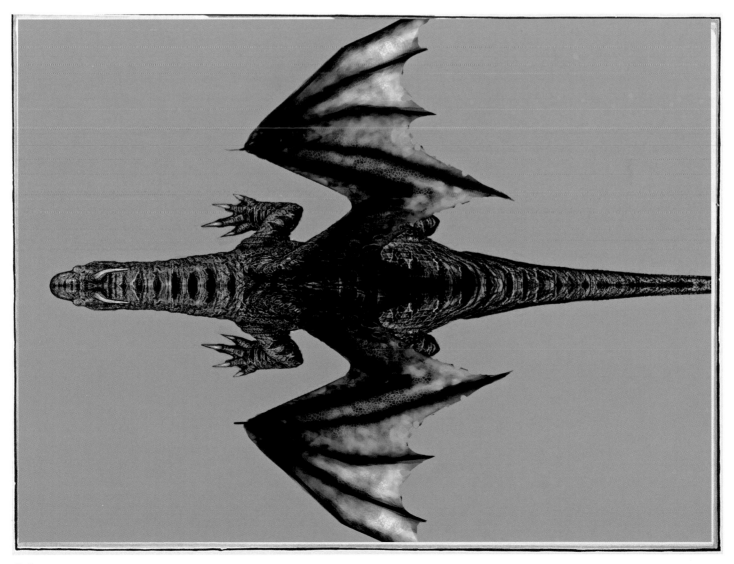

Fig 6.

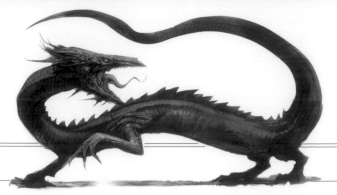

CHINESE FIREBALL

Second to draw his dragon during the first task of the Triwizard Tournament is the Durmstrang Institute champion, Viktor Krum. Viktor pulls out the Chinese Fireball. The concept artists took into account that iconic dragons from different countries may have different looks, as seen in the more lizard-like body of the Chinese Fireball.

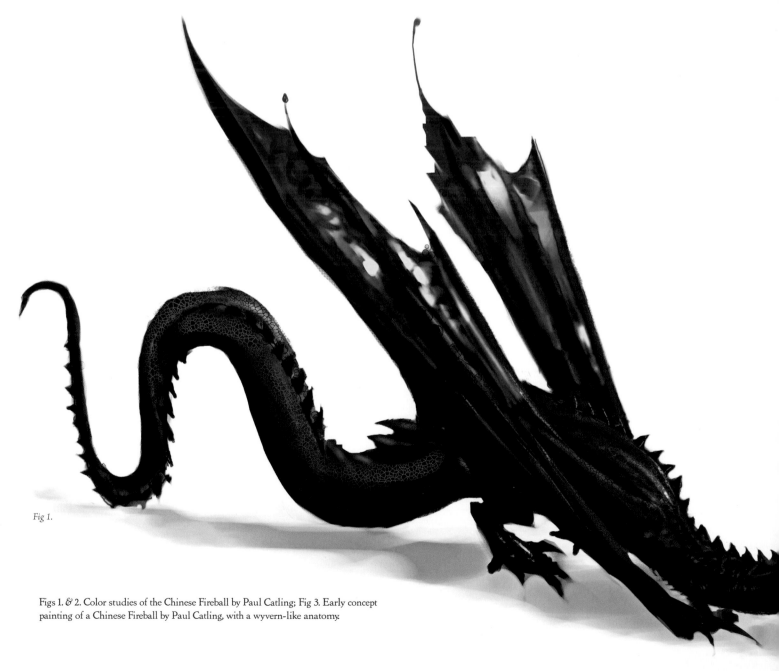

Fig 1.

Figs 1. & 2. Color studies of the Chinese Fireball by Paul Catling; Fig 3. Early concept painting of a Chinese Fireball by Paul Catling, with a wyvern-like anatomy.

FAST FACTS

CHINESE FIREBALL

✴

I. FILM APPEARANCE: *Harry Potter and the Goblet of Fire*

II. LOCATION: Triwizard Tournament arena

III. DESCRIPTION FROM *HARRY POTTER AND THE GOBLET OF FIRE* BOOK, CHAPTER NINETEEN:

"There was . . . a red one with an odd fringe of fine gold spikes around its face, which was shooting mushroom-shaped fire clouds into the air . . ."

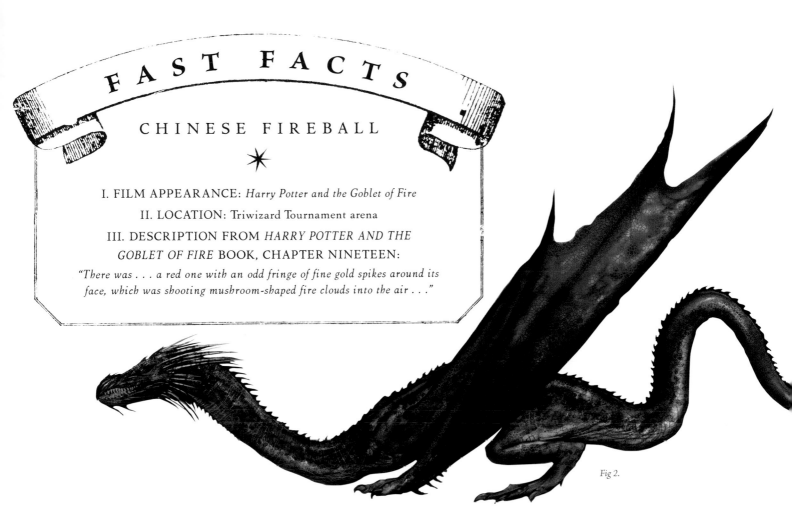

Fig 2.

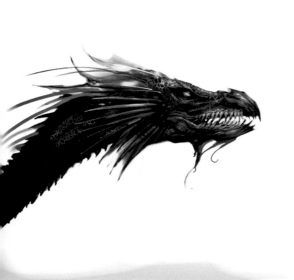

Fig 3.

SWEDISH SHORT-SNOUT

Cedric Diggory, the first-selected champion for Hogwarts, picks the Swedish Short-Snout during the first task of the Triwizard Tournament. The designers of the Swedish Short-Snout experimented with widely diverse approaches, though recognizing that, of course, the focus needed to always be about the dragon's most distinctive feature—its short snout.

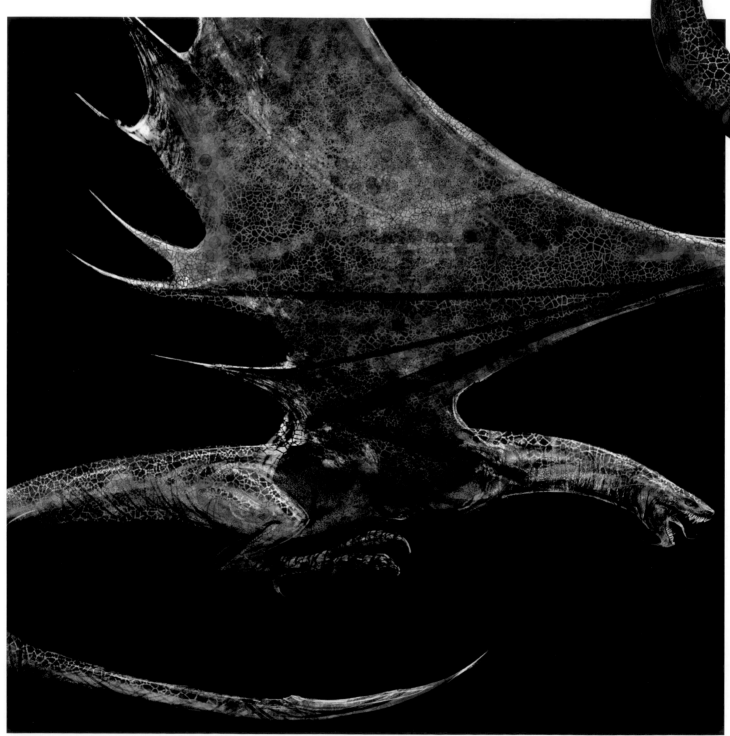

Fig 1.

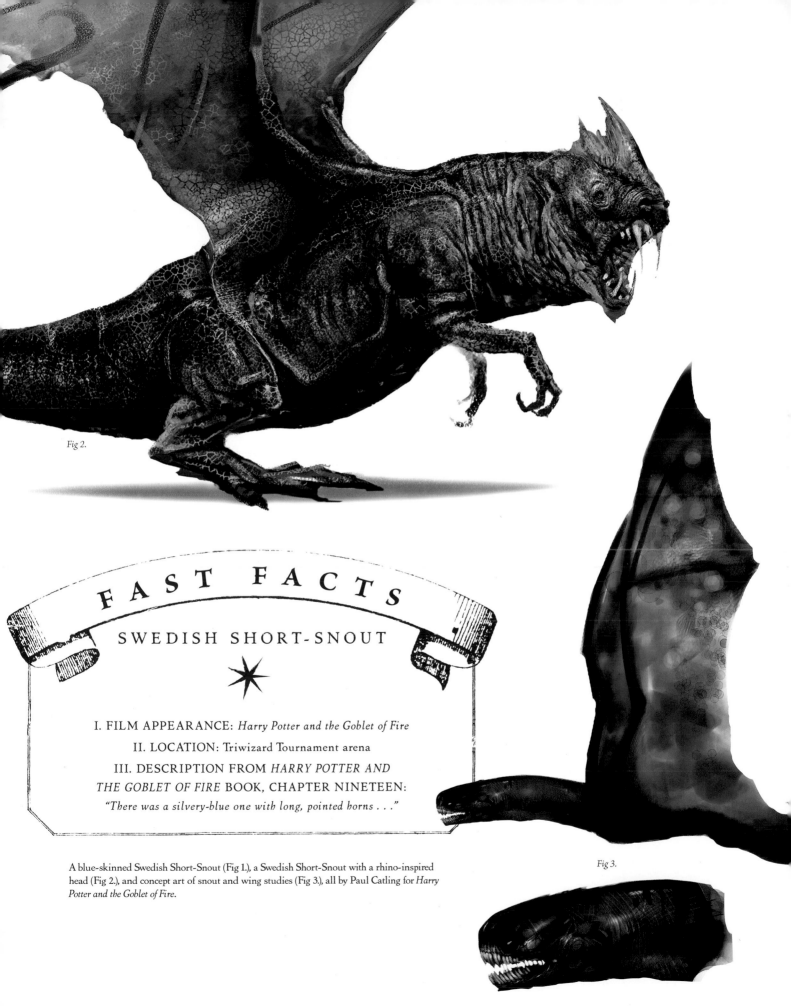

Fig 2.

FAST FACTS

SWEDISH SHORT-SNOUT

✶

I. FILM APPEARANCE: *Harry Potter and the Goblet of Fire*

II. LOCATION: Triwizard Tournament arena

III. DESCRIPTION FROM *HARRY POTTER AND THE GOBLET OF FIRE* BOOK, CHAPTER NINETEEN:
"There was a silvery-blue one with long, pointed horns . . ."

A blue-skinned Swedish Short-Snout (Fig 1.), a Swedish Short-Snout with a rhino-inspired head (Fig 2.), and concept art of snout and wing studies (Fig 3.), all by Paul Catling for *Harry Potter and the Goblet of Fire.*

Fig 3.

UKRAINIAN IRONBELLY

In the lowest level of Gringotts Bank, visited in *Harry Potter and the Deathly Hallows – Part 2*, a Ukrainian Ironbelly dragon guards the treasure vaults of the oldest and richest wizarding families. The goblins control this neglected, angry dragon with threats of pain, so the filmmakers needed to give this creature the appearance of a captive. To gain access to the Lestrange's vault, Harry Potter, Hermione Granger, and Ron Weasley, with the help of Griphook, must get past the Ironbelly, and then, to escape, they must fly the dragon out of the bank to freedom.

The Ukrainian Ironbelly that lives in the cavernous cage of vaults beneath Gringotts Bank in *Deathly Hallows – Part 2* needed to have rust-tinged scars from its chains. The creature's coloring had faded to a sickly white, and it was partially blind from living in the dark. It's emaciated from lack of care and years of maltreatment. As a result, it's very dangerous—and very different from most dragons seen on-screen.

It was important to have the Ironbelly look unhealthy, but not so much that you couldn't feel sympathy toward it.

CGI started with a defined skeleton, layered with a simple muscle frame. Digital animation allowed the muscles to deform and then inflate or deflate the skin so it "slid" between the bones and muscle. Tendons were then laid across its neck, shoulders, and hips that were each independently controlled for a shifting movement, and it was enhanced by another control for the dragon's veins underneath the thin skin. There was even a "wobble" control for loose skin under the dragon's neck.

Unlike the Hungarian Horntail in *Harry Potter and the Goblet of Fire*, the Ukranian Ironbelly was not created as a full-size model by the creature shop. However, the dragon still needed to be ridden. So a section of its torso, twelve foot long at full scale, was constructed and covered with a silicone hide. This was mounted on a motion-based gimbal programmed with the movements of the digital dragon flying away from the bank. The section contained fully jointed shoulders that moved in sync with the flapping of the dragon's wings.

Fig 1.

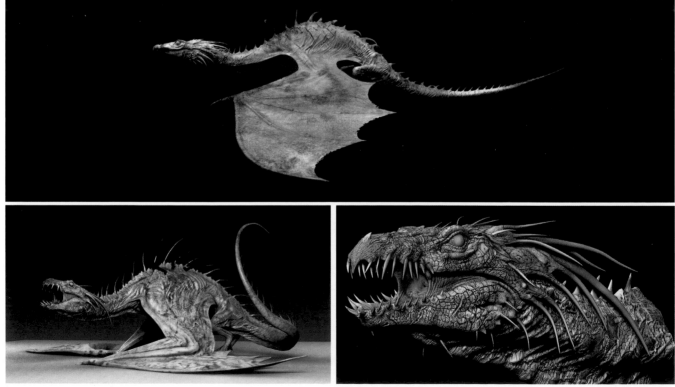

Fig 2.

Fig 3.

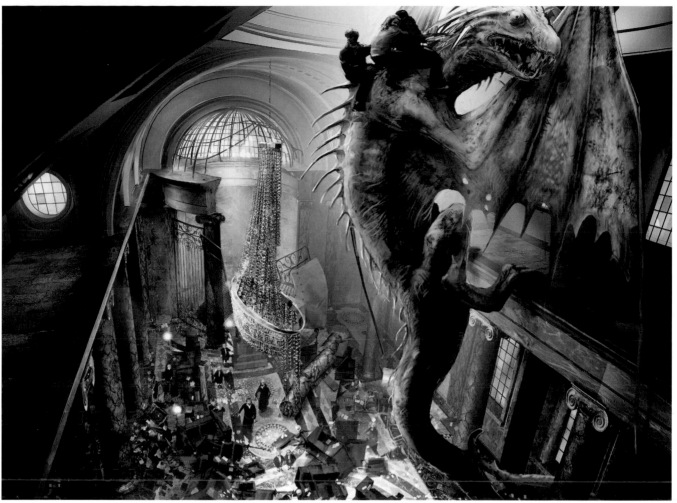

Fig 4.

FAST FACTS

UKRAINIAN IRONBELLY

✦

"That doesn't sound good."

— RON WEASLEY

Harry Potter and the Deathly Hallows — Part 2 film

I. FILM APPEARANCE: *Harry Potter and the Deathly Hallows — Part 2*

II. LOCATION: Gringotts Wizarding Bank

III. DESIGN NOTE: The animators made the dragon's skin an anemic grayish-white, without any green or blue tones.

IV. DESCRIPTION FROM HARRY POTTER AND THE DEATHLY HALLOWS BOOK, CHAPTER TWENTY-SIX:

"Harry could see it trembling, and as they drew nearer he saw the scars made by vicious slashes across its face . . ."

Fig 1. Study of the Ironbelly's coloration and aging by Paul Catling; Fig 2. The Ironbelly with silhouetted figures astride by Paul Catling; Fig 3. Study of the Ironbelly head by Paul Catling; Fig 4. Concept artist Andrew Williamson's painting of the Ukrainian Ironbelly escaping from Gringotts Bank as Hermione, Harry, and Ron hold on, for *Harry Potter and the Deathly Hallows — Part 2*.

ISBN: 978-1-68383-746-6

INSIGHT
EDITIONS

PO Box 3088
San Rafael, CA 94912
www.insighteditions.com

Publisher: Raoul Goff
Associate Publisher: Vanessa Lopez
Creative Director: Chrissy Kwasnik
Editor: Greg Solano
Editorial Assistant: Jeric Llanes
Senior Production Editor: Rachel Anderson
Senior Production Manager: Greg Steffen

Text by Jody Revenson

 REPLANTED PAPER

Insight Editions, in association with Roots of Peace, will plant two trees for each
tree used in the manufacturing of this book. Roots of Peace is an internationally
renowned humanitarian organization dedicated to eradicating land mines
worldwide and converting war-torn lands into productive farms and wildlife
habitats. Roots of Peace will plant two million fruit and nut trees in Afghanistan
and provide farmers there with the skills and support necessary for sustainable
land use.

Manufactured in China by Insight Editions

10 9 8 7 6 5 4 3 2 1

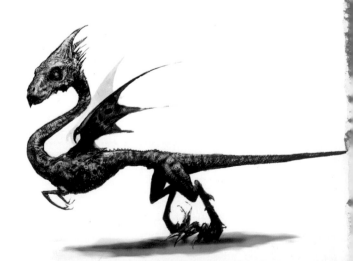